☜ **W9-DJN-709**

St. Louis Community College

Library

5801 Wilson Avenue
St. Louis, Missouri 63110

Zoltan Szabo

ARTIST AT WORK

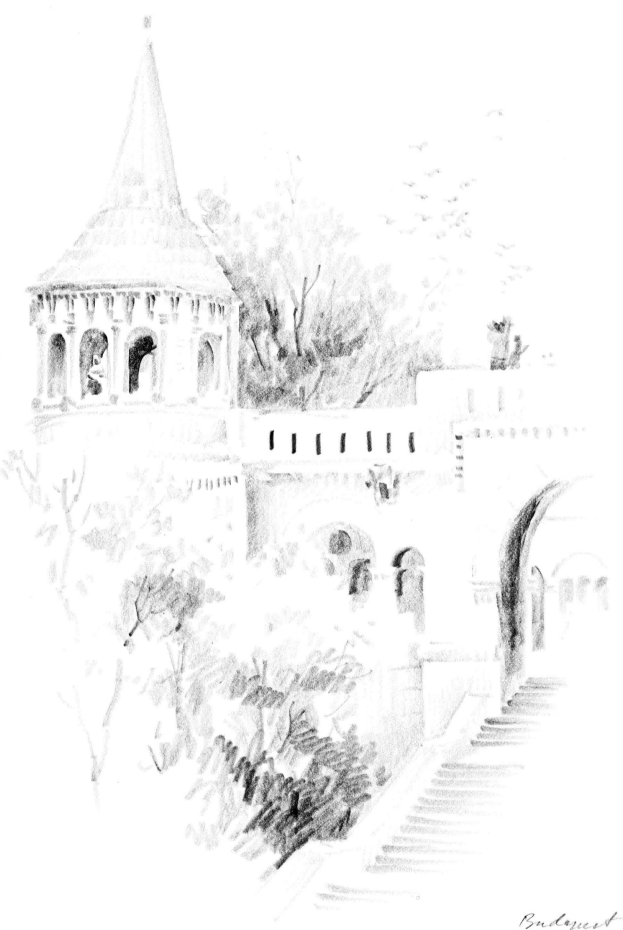

Budapest

Zoltan Szabo

ARTIST AT WORK

BY ZOLTAN SZABO

WATSON-GUPTILL PUBLICATIONS/NEW YORK
PITMAN PUBLISHING/LONDON
GENERAL PUBLISHING CO. LTD/DON MILLS, ONTARIO

Editor's Note: The pencil and watercolor sketches in the interview section are reproduced from pages in the author's numerous sketchbooks. Paintings in the demonstration and one-man show sections are on half sheets (15 x 22 inches/38 x 56 cm) of 300-lb cold-pressed Arches watercolor paper.

First published 1979 by Watson-Guptill Publications,
a division of Billboard Publications, Inc.,
1515 Broadway, New York, N.Y. 10036

Library of Congress Cataloging in Publication Data
Szabo, Zoltan, 1928–
 Zoltan Szabo, artist at work.
 Includes index.
 1. Szabo, Zoltan, 1928– 2. Water-colorists—
Canada—Interviews. 3. Water-color painting—Technique.
4. Landscape in art. I. Title.
ND1843.S97A4 1979 759.11 79-16097
ISBN 0-8230-5977-4

Published simultaneously in Great Britain by Pitman Publishing Ltd.,
39 Parker Street, London WC2B 5PB
ISBN 0-273-01446-3

Published simultaneously in Canada by General Publishing Co. Ltd.,
30 Lesmill Road, Don Mills, Ontario, Canada M3B 2T6
ISBN 0-7736-0077-9

Manufactured in Japan

First Printing, 1979

DEDICATION

Our philosophy of life and the way we apply it represents human values that our fellow men and women judge us by. Like many of you, I am constantly in the process of developing a personal philosophy that will let me dream, grow, and aim for faraway stars. Those shiny little flickering lights may seem unreachable at first, but they have an obliging tendency to keep glistening invitingly until at last I can believe that I actually may touch them.

In my lifelong evolutionary trip, my paintings, the products of my creative growth, represent a series of stages along the way. This book contains a collection of them for you to look at and enjoy. I hope to communicate to you through their visual qualities the emotional experiences that I felt while I painted them. I also hope that they reflect my love of God's nature through the enchanting beauty of transparent watercolor.

As a spiritual bouquet, I offer them to all of you, but especially to the one dearest to me, my little wife Linda. Her constant encouragement, patience, and inspiring, unselfish companionship really made the birth of this book possible. To her, as your representative, I lovingly dedicate this book. I am sure that by sharing it with all of you, it will become a more precious gift than if I had given it to her alone.

ACKNOWLEDGMENT

I wish to express my gratitude to those fellow painters who honored me by inviting me to conduct watercolor seminars for them. As some of the following paintings may remind them, my growth as an artist has been enhanced by these wonderful experiences.

Also, my most sincere thanks to Don Holden, Editorial Consultant; Marsha Melnick, Editorial Director; Bonnie Silverstein, my little editor; and Bob Fillie, graphic designer of this book. Their truly professional attitude, as well as that of Hector Campbell, who was involved with the production, made this, my new dream come true. Most of all, I thank the great Critic above who allowed me to have the opportunity and good health to complete the job.

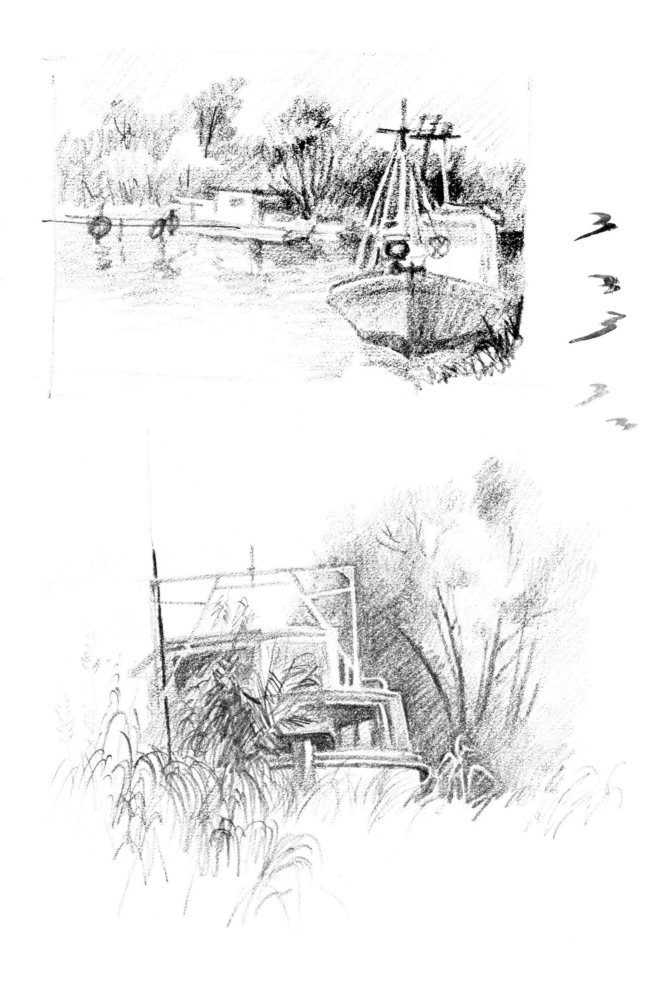

Contents

An Interview
with the Artist

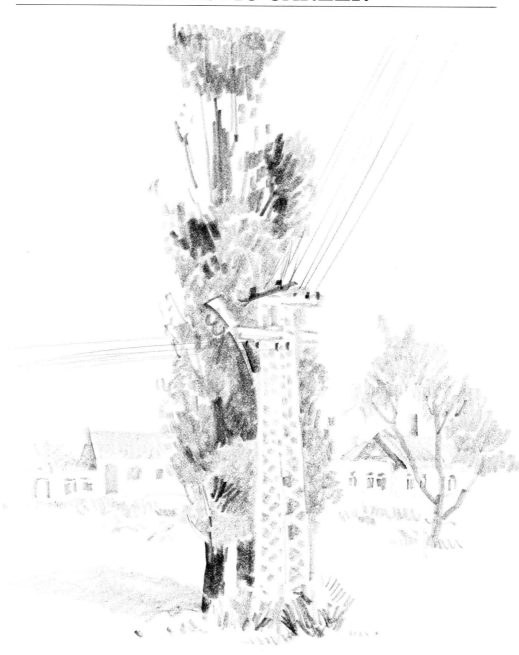

When did you first know you wanted to be an artist?

I always dreamed of it. Apparently my mother couldn't keep me on the potty "long enough" unless she supplied me with plenty of paper and colored pencils. When the war tore up my homeland, Hungary, my teenage years were interrupted, but my interest in art wasn't disturbed at all. I used to drool over some of the lovely war illustrations in magazines. I really can't remember most of the subjects, but I can still clearly recall the style of many artists of the forties, surprisingly from both sides of the war. I guess this was the time when I realized that I had my own ideas and felt like communicating them "skillfully." I grew more and more determined to gain this skill and be an artist, and made the final plunge in my late teens.

Where did you get your artistic training?

I loved drawing and enjoyed working with paint all my life. In high school, art was compulsory and taken very seriously. I had an enjoyable start during

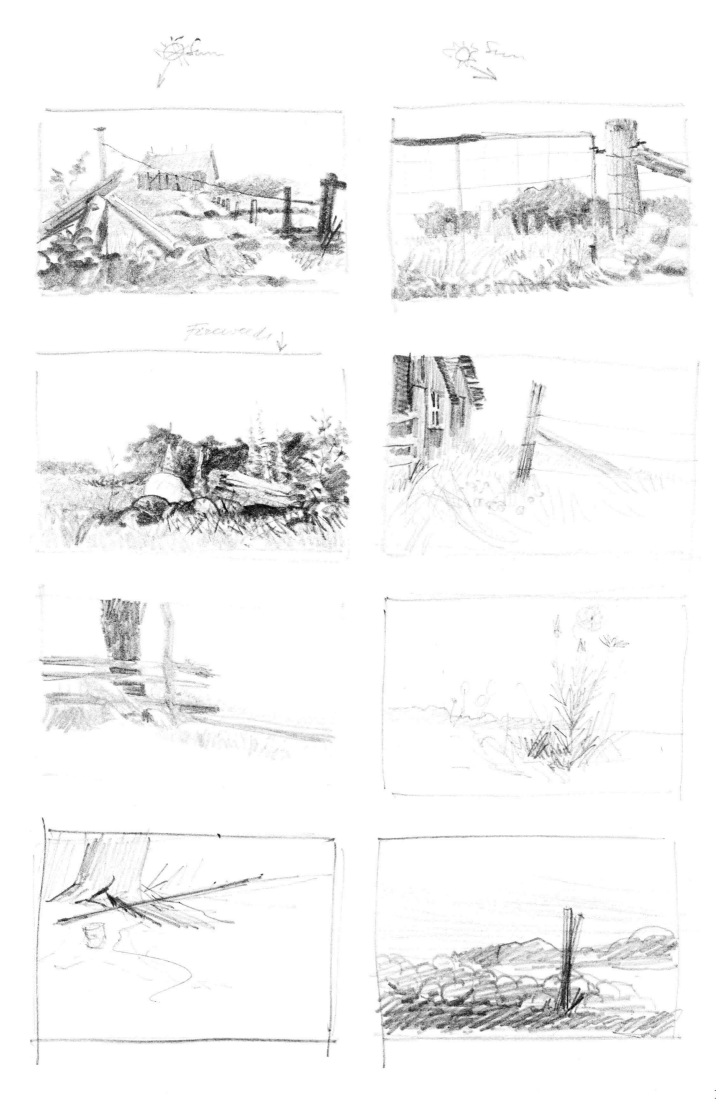

Fireweeds ↓

11

these years. The program was designed to teach technical control of the hand; otherwise, craftsmanship was the goal. After high school and the Second World War, I decided to be an artist. I was eighteen. After just one year in the Academy of Industrial Art in Hungary, I had to leave my country to find a better future in America. Canada gave me a home and a wonderful future. I lived there for twenty-nine years, and developed my skill and philosophy as a watercolor artist there—I was a commercial artist as well as a painter for fifteen years. This way I had the financial security to raise my children, as well as a chance to train myself on the job, so to speak. I painted in my free time as often as I could.

Who did you study with and what kind of training did you have?

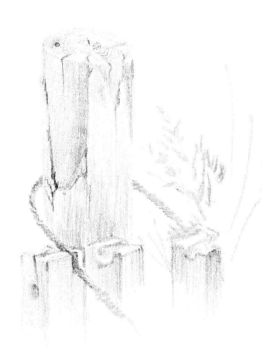

I can't drop big names. Two of my high school teachers, humble but very devoted artists, taught me many of the basics. In art school I was surrounded with great teachers who continued to refine my technical disciplines. In Canada I worked with good artists. One I'm especially grateful to is Sid Dyke of Vancouver, who encouraged me a great deal to paint with watercolor. He's an excellent, inventive painter and a sincere friend. His early influence is the most outstanding in my mind. I also read Eliot O'Hara, Ted Kautzky, and Rex Brandt books with great thirst, and I took the Famous Artists' course, but essentially, I taught myself by working all the time and trying to learn from my mistakes. I feel that when you create, you have to be and are alone even when dozens of people are watching you. We can be our own best teachers if we're willing to think while we work.

Did you study all media or did you concentrate only on watercolor?

In high school we were allowed only to draw and later to use watercolor. In art school, I used all major media. In my early career in Canada, I painted with both oil and waterbased media, but most often with transparent watercolor. Somehow my personality was always most compatible with watercolor. The challenge of this untameable medium squeezed out my love of all others, except for pencil drawing.

When you first came to Canada, did you work as an artist right away?

I had a real break. Two weeks after my arrival in Canada I got a job in the art department of a small printing house, even before I could speak English. This is where Sid Dyke was my art director. I also lived and worked in a nearby farm for the first year to fulfill my farm contract with the Canadian government for bringing me to the promised land.

What made you decide to devote yourself to painting?

During my years of gradual growth as an artist, my need to express my ideas became more and more apparent. When the public started to buy my work, I realized that I was communicating with them successfully. Besides a good income, my commercial art offered many frustrations beyond my control. I decided that if I ever reached the point where my painting income (earned with left-over energy after a full day's work) matched my commercial income, I'd quit the commercial job. I thought that this ambitious condition was not likely to happen, but it did. You'd have to know the dynamic support of the people of Toronto to understand how this occurred. At that point I did what I'd promised myself; I started to paint in watercolor full time.

Once you made that decision, what did you do to get started?

I worked like hell. I reached for any opportunity that offered itself: outdoor shows, gallery exposure, solo shows, and group shows. I also taught art in winter programs and in seminars locally as well as in nearby cities. But the greatest boost came when I got a chance to publish my first book, *Landscape Painting in Watercolor,* by the best art publishing house in the United States, Watson-Guptill Publications. Thanks to its Editorial Director, Don Holden, who gave me a chance to introduce myself to all of North America, my career shot up and has been on the rise ever since. Finally, the years of self-training, learning from here, there, and everywhere, bore an unexpected harvest. I developed some techniques that were unique, even though I was not aware of them until the response from the readers of my book pointed them out. Since then I have been just trying to grow a little every time I paint.

How did you begin to build your reputation?

Exposure is a personal thing. By selling the best paintings that I could produce, my name was spread by their new owners. It was a slow, but sure, process. All my best opportunities resulted from these unexpected contacts. Suddenly it was happening all around me. Some of these original customers became dear friends and collectors of my and others' work. Three friends went as far as contracting all my work for two years during the most critical time of my development. They managed to acquire some of my major works along with lesser ones, but it was the best I could do at the time. The galleries followed, but they were of only secondary importance.

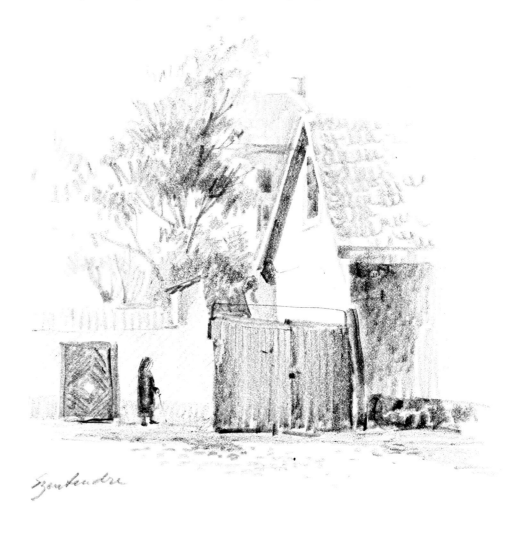

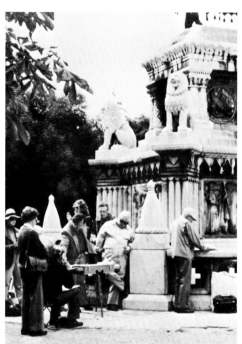

Did you combine painting with teaching right from the start?

Teaching came after a lot of painting, after an awful lot of it. I had to have something worth teaching first. I painted for about fifteen years before I thought of teaching. A few beginner artists who liked my painting asked me if I would teach them. I tried it and liked it. Evening classes followed, and I became more and more comfortable with people. I enjoyed watching others learn and grow. In the meantime, I reinforced my own theories by testing them with others. When I moved to Sault Ste. Marie, Sault College invited me to join their faculty. I did, and spent five wonderfully happy years there as a teacher, with an impressive productivity in my resident artist's studio. In other words, I got a lot of breaks and I tried to make the best of them, for me as well as for those who offered them.

Why do you like to teach? Does it help you in your own work?

Teaching complements my work. I've spent the last three years traveling and teaching one workshop after another. This involved doing demonstrations practically every day. I'm exposed to some excellent artists and I make sure that my work shows them my honest best without holding back. At the same time, I carefully think out my approach. Each time I try to offer something new. If I get a new idea, I can hardly wait for the next class to show it to my new friends so that they can try it out too. Teaching makes me more inven-

tive and exposes me to new ideas and new environments. It's tiring, but it's also very exciting and rewarding. People, particularly watercolorists, are wonderful.

How do you teach?

I both lecture and demonstrate. First I describe my ideas on a chosen subject. I generalize a little, but try to close in on a lot of specifics. Then I follow this with an appropriate demonstration. I try to explain very carefully not only what I'm doing as I paint, but *why* I'm doing it. When my demonstration is completed, I sum up the result. Then it's the participants' turn. They paint a related subject for a few hours. I help those who need it, but try not to encourage them to paint as I do. I respect their individuality and try to help them develop technically so that they'll be better equipped to express that individuality. I never try to tell another artist what to do on his or her work. This must be the individual's decision. I'm there to tell only how it may be done. I show what I can't tell. A picture is worth

What do you teach beginners, intermediates, and advanced water-colorists?

Well, it's in the books—my books! For the beginner, I teach basic technique with a strong emphasis on values and just a few colors. The palette in *Landscape Painting in Watercolor,* which is for the beginner and early intermediate painter, contains grays to avoid the confusion of mixing complementary colors, yet still guarantees a good control of values. For the intermediate painter, I get into composition a little—I use the word "shapes" constantly—and discuss color qualities more (see *Zoltan Szabo Paints Landscapes: Advanced Techniques in Watercolor).* We also polish up technique. Finally, in teaching advanced painters, I reach for the unusual in technique. Here individuality is a must! The idea I try to put across is for them to try my way and decide if they like it. Some of my techniques are new to advanced students, and if they can use them, they can adapt them to their own style. In my advanced workshops we exchange ideas, spell out philosophies, and paint, paint, paint. . . !

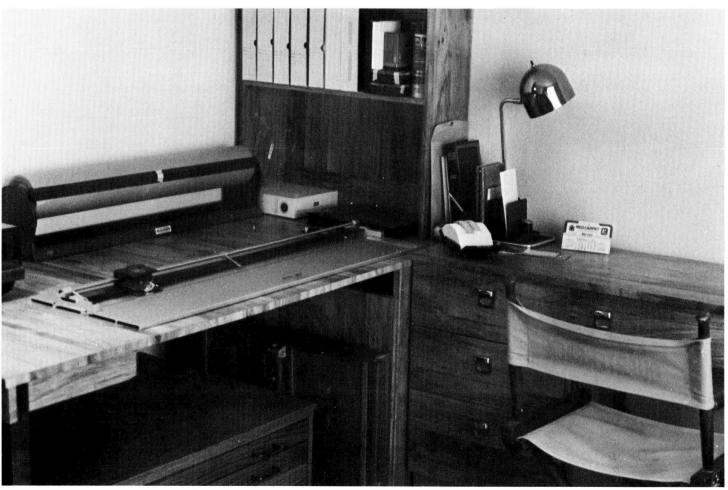

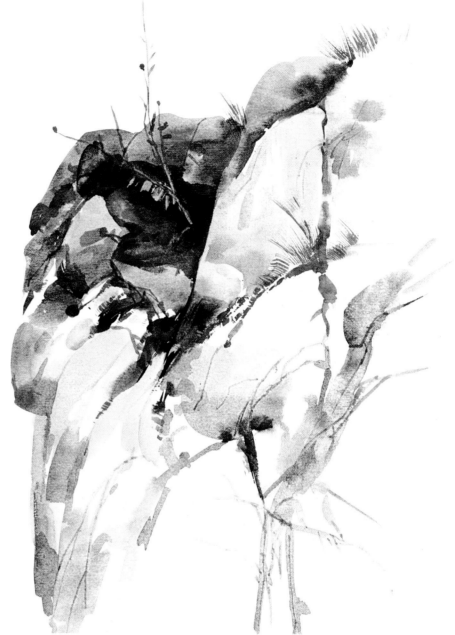

What does your studio look like?

I have two studios, one in my home and a big one under the sky. My home studio has a large drawing board to paint on and a stool. I also have a taboret (high cabinet) to hold my palette, colors, and brushes—in one word, my tools. I have a sink with hot and cold water, and lots of surfaces for spreading things around; storage space for paper and mats; a large guillotine for cutting paper; and storage for frames and finished work. I have a bench with a small press for my "aquagraph" prints, described in *Creative Watercolor Techniques*. There's also a cozy little corner where I'm surrounded with books, my slide collection, projectors, a low soft chair and table, and a good hi-fi and tape. This is my thinking corner, and I love to think and work with quiet, light classical music. I also have a model stand for figure studies with electrical outlets all around it for spotlights, and a private corner for the model to change in. There's also a secretarial desk, chair, and file, and, finally, a washroom with a shower. What I don't have is a telephone, mail chute, television, or other distracting elements.

In terms of lighting, I like the place to swim in light while I work. There's lots of indirect light coming in through high windows from different angles, with north light over my drawing board. I also have white floodlights all over on strips, plus four bars of cooler daylight fluorescent bulbs. But there's no substitute for daylight. However, I try to match the color of my artificial lights to be just a little warmer than cool daylight. I like lots of light in my painting area, but just a spot or two in my thinking corner.

What watercolor brushes do you use? What do you use each one for?

I have two sets of brushes: those that I use to paint with and those that I use to brush on clean water only. My painting brushes are a 2-inch (5-cm) soft oxhair flat brush for large washes and a 1-inch (2.5-cm) pure sable flat brush for well-controlled washes or glazes. I have two nos. 6 and 8 sable brushes, with points for details. My rigger (a long-haired, slim, sable brush) is for thin, long, calligraphic brushstrokes. I have a 1-inch (2.5-cm) and a ¾-inch (2-cm) hog bristle brush for painting rich colors and firm shapes on wet paper and also to brush dark colors with in order to lift out color (recovered luminosity). I have a palette knife with a round flexible tip and a firm part at the heel to texture the paint by lifting off excess color or to apply firm branches, twigs, or weeds.

On the clean water side (my left), I have a big 4-inch (10-cm) flat bristle brush for wetting the paper. I also have 1½, ¾, ⅜, and ⅛-inch (4, 2, 1 and 0.3-cm) bristle brushes for applying clear water, for losing edges, and for wetting and lifting out dark colors. These brushes are cleaned with tissue each time they touch color on the painting to prevent even the slightest pollution of the clean water supply. The water in the dish on my left must stay clear enough that I could drink from it even after the painting is finished. (Incidentally, I often do drink it outdoors.)

What are your favorite watercolor papers?

I prefer 300-pound cold-pressed (medium rough) Arches paper. It's a pure rag paper with a consistent quality. The surface is just the right texture for me. It has a hard finish and it can withstand a lot of lifting with a brush or knife. I also like its warm white hue. The paper is available in 140- or 90-pound weights as well, but I like the heavier 300-pound because it holds the moisture longer than the thin ones and it doesn't buckle as much.

Even though I prefer cold-pressed paper, I occasionally use a rough or a smooth, hot-pressed paper. I choose the rough paper when I intend to paint with a coarse drybrush technique. On the other hand, on hot-pressed paper, which is extremely smooth, granulating colors (like raw sienna and cerulean blue) separate beautifully into exciting patterns. Also, a flat wash is textured more on hot-pressed paper than on a rougher surface, so when I want this effect, I use hot-pressed paper. Drybrush is almost impossible to do on it, though, and if it does happen, it's so gentle that it's hardly noticeable. Hot-pressed paper is extremely good for detailed work and calligraphic touches. But it's easy to slip into tightness on it; consequently, I watch the progress of my work so I don't get carried away.

What's your working surface?

In my studio I use a large drawing board; outside, I use an easel of my own design (see page 22). Both in the studio and outdoors, I mount my dry paper

onto a piece of Masonite with masking tape. By mounting it, I can tilt the paper with the support board any time I want, without having to tilt the work surface. Also, the Masonite is firm and forces the dry-mounted paper to flatten out after the washes I paint on it dry.

What other tools do you paint with?

I wrote a whole book on all the tools I use; it's all spelled out in *Creative Watercolor Techniques.* Some of my special favorites are as follows: My flexible palette knives are great little tools for branches, weeds, and any linear strokes that occur in nature. I use their edges or tips for applying color. I use the heavier, widest part (heel) to texture surfaces by squeezing excess color off in the desired area, and then by pressing hard, I prevent the remaining wet paint from re-entering the squeeze-dried light shape. They're great friends of mine, and I use them all the time. I use salt for texturing ice, snowflakes, and such. I use wax (a resistant) or liquid latex for masking. A sponge is used to texture the mottled effect on rocks, moss, and so forth. I use these only occasionally, and if the subject calls for it, I'll use anything, even a razor blade. However, I never let any tool become a crutch.

How do you arrange your materials and tools on your working surface?

My paper is in front of me, about 36 inches (91 cm) from the ground, a comfortable height for me when I stand. I'm right-handed, so my painting brushes as well as my wet paper pad, my palette, and the mixing water are on my right. On my left, *very handy,* is my box of paper tissues, my clear water brushes, and another dish of clear water.

Do you use anything to speed the drying process?

On location I often have the sun or the heater in my car, if I'm close enough to it. In my studio, I use the heat from a strong light bulb or a heavy-duty hair dryer. I'm cautious in using the light bulb because if the paper gets close enough, the bulb can scorch it.

What is your color palette?

My palette is divided into two halves: essential colors and luxury colors, all Winsor & Newton artist-quality pigments. I can't be without my essential colors, but if I had to, I can mix those on the luxury side. However, since it's the quality of the paint that counts, particularly in the case of those on the luxury side, I prefer to use the tubed color instead of mixing a comparable hue.

My essential colors are:	My luxury colors are:
New Gamboge	Aureolin Yellow
Raw Sienna	Cadmium Orange
Burnt Sienna	Cadmium Red Medium
Brown Madder (Alizarin)	Alizarin Crimson
Sepia	Cobalt Blue
Antwerp Blue	Sap Green
Manganese Blue	Winsor Blue
French Ultramarine Blue	Cerulean Blue

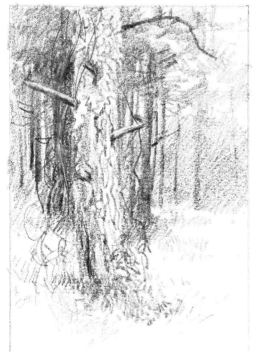

My palette has gone through a lot of changes and grown with me until I arrived at this one. It's a practical combination of colors for my way of work. I know their nature well and never change their location on my palette. (I devoted an entire chapter, including a color chart, to them in *Zoltan Szabo Paints Landscapes.*) All these colors are transparent when well diluted with water, though some may be opaque when applied thickly. When I glaze color over dry washes, I use my most transparent ones. If I intend to lift out darker hues from a wash, I make sure that a staining color dominates the mixture so its hue remains after the other colors are lifted. For example, when I'm painting a shallow creek bed and anticipate lifting out the ripples in the water above, I paint the bottom of the creek with a mixture of burnt sienna and sap green, which together makes a lovely dark green color. When the wash is dry, I can rewet it and lift out the darker brownish color and leave the green (which represents the foliage reflected in the water), because sap green is a staining color, while burnt sienna is not.

I also use other colors in special ways. I use separating or granulating colors such as raw sienna, manganese blue or cerulean blue for dotted textures such as sand or sparkling snow in the shadow. Whenever I expect to lift off a color, I try to include manganese blue in the mixture. It can be wet-lifted out completely, even after it's dry, and it makes other colors come off more easily too when it's mixed with them. When I use the more opaque colors—such as cerulean blue, sepia, and the two cadmiums—I use restraint and dilute them well.

Do you have any preferred colors or color schemes?

All the colors on my palette are friends. However, raw sienna, Antwerp blue, burnt sienna, brown madder, and French ultramarine blue are the colors I use the most—so I guess they're my favorites. I like to mix brown madder

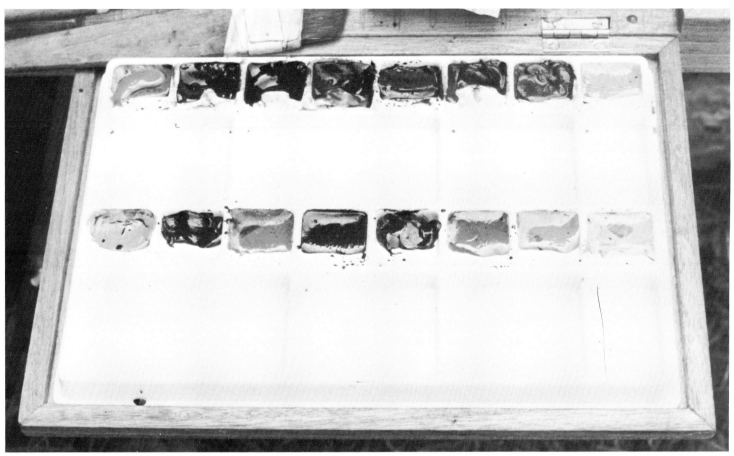

The new Szabo watercolor palette.

with Antwerp blue or French ultramarine blue with burnt sienna for grays. Both combinations can easily lean towards cool or warm temperature, depending upon which pigment dominates. I also enjoy the staining effects of sap green when it's recovered from a mixture with other darker colors. I use only a few colors for each painting; seldom more than six. I pick a mini-palette for each painting before I start by first analyzing the idea and then choosing the colors that will give me the most versatile result. Once selected, I never deviate from these colors while I paint. This way my color unity is assured.

Do you mix your colors on the palette or on the paper?

I start the mixing on my palette and get an idea of the color by glancing at my brush, but complete the final mix on the paper because the reflective strength of the palette differs from the final illuminating whiteness of the paper. I work out and finalize my colors on the paper where I can see *exactly* what they look like. The palette is always the same, but papers vary from brand to brand and even from batch to batch. It doesn't do me any good to be able to mix a color that looks good on the palette and, for example, on Arches cold-pressed paper, if I happen to be painting on Fabriano. I have to see and judge the color on the paper I'm actually painting on.

What kind of watercolor palette do you use?

I use the original Szabo watercolor palette, that's my own design. It has sixteen wells into which I squeeze my colors. Next to the wells are various sized slanted square mixing spots. I like these *slanted* squares because I often paint with my palette knife, and it's easier to dip my knife into pooling liquid paint than into color on a flat surface.

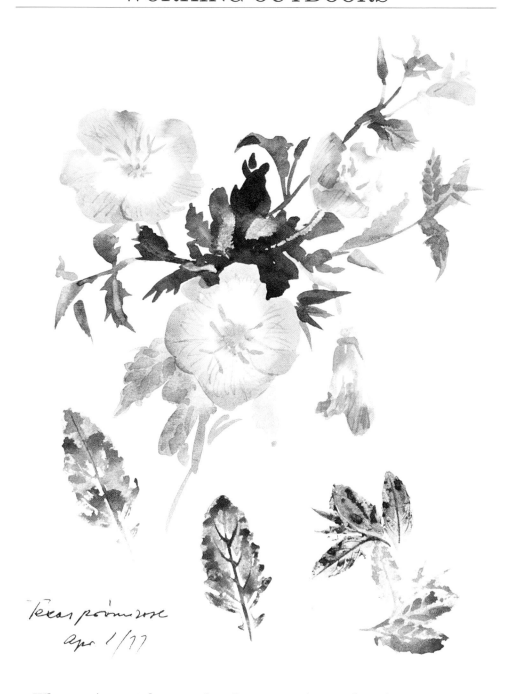

Texas primrose
apr 1/77

What equipment do you take when you paint outdoors?

When painting outdoors, I use an easel of my own design, the Szabo easel, which is sold commercially together with the Szabo watercolor palette (which fits it exactly). (Artists can now purchase my easel and palette from SZ Enterprises, P.O. Box 736, Saulte Ste. Marie, Michigan 49783.)

Other than the easel, I use the same equipment indoors and out. I pack everything in the easel except a big plastic jug of water and a box of paper tissues. It has two drawers to hold my palette, brushes, and other tools. Inside I have several sheets of paper and my sketchbook. When I paint, I like a flat surface most of the time (though the top of the easel can be tilted). I pull out both side drawers halfway. On my right, the drawer has a hinged flap that folds out to hold my palette and a damp paper pad. I have a place for my brushes, plastic "mixing water" container, and wet paper pad in the exposed part of the same drawer. In the half-opened left-hand drawer, I keep a box of

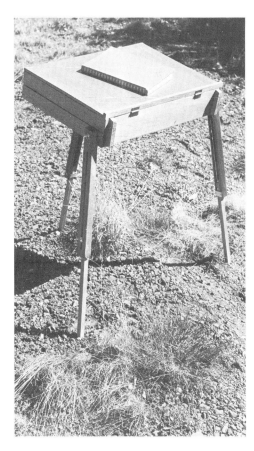

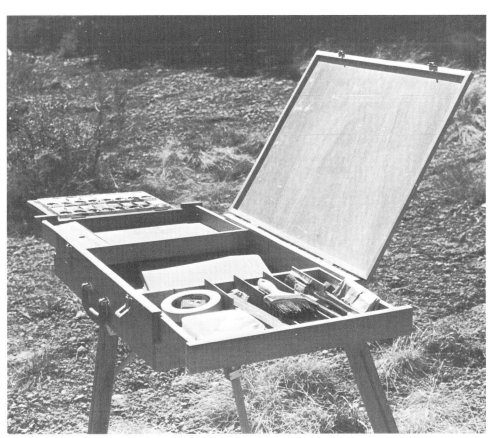

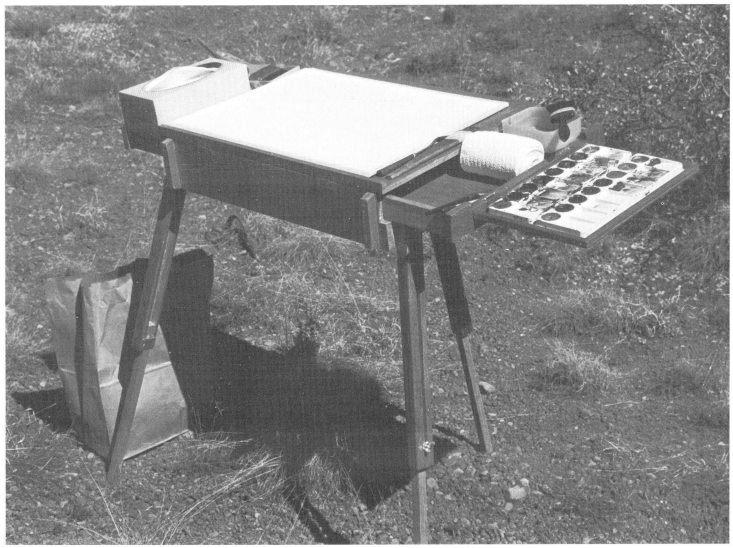

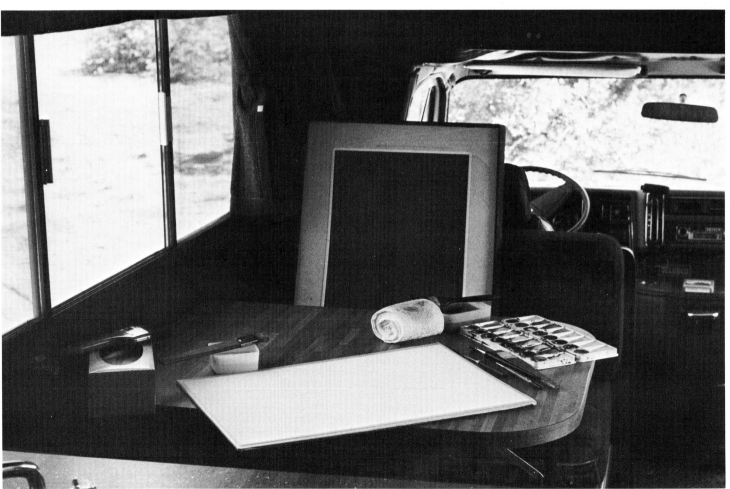

paper tissues, a set of brushes used only with clean water, and another plastic container with clean water only.

My easel is not only practical to use, but it sets up anywhere in little time. By adjusting any or all three legs, I can have a level surface, even on slanting or rough ground. (I use my translucent water container as a level to make sure the surface of my easel is flat.)

How do you carry all your materials and equipment?

My easel can be mounted on a backpack frame, but I usually drive to location and walk from the car holding my easel by the handle. I carry my easel in one hand and a plastic bag with my water jug, and tissue box in the other. The bag also serves as a waste container to throw my discarded tissues in. I despise people who throw paper and Polaroid clutter all over the place. It's not only ugly, but animals eat it and it kills them. To prevent my bag from blowing away while I paint, I put a small rock in the bottom.

Do you stand or sit when you paint outdoors?

I always stand. I feel that the natural bobbing motion of my body prevents me from getting too close to my work surface for too long. If I feel tired, I sit anywhere, but while I work, I prefer standing. Naturally I sit if I paint in the car, but if I'm painting in my motor home, I work standing in there as well.

How do you keep from freezing in really cold weather?

I dress warmly, but I'm fortunate to have really good circulation, and I can stand a lot of cold. I can do my drawings or graphite washes without gloves, but I can't stop the water from freezing on the paper. This means that I don't paint with watercolor if the temperature is below 28° F (−2° C). I also make sure that my feet are warm, so I wear felt-lined boots.

How does painting outdoors affect your work?

The fresh air and experiencing the real thing loosens me up. I really enjoy on-location painting, and somehow it shows in my paintings. The freedom of nature demands fresh techniques. If I do lots of painting from nature, my studio work also gets fresher. I couldn't be happy painting indoors all the time.

Is there any difference between your studio and outdoor paintings?

I hope not, since I do both all the time, and I only paint subjects that I've experienced outdoors. In my studio, I dream and ad lib a lot. My studio paintings have a little more of me in them, but they're the fruits of one or several earlier outdoor experiences. Inside, where conditions are ideal, I have time to play and plan more carefully. I suppose at first glance these larger paintings appear more polished because I painted them in comfort indoors without the pressure of time. My studio work is also more daring, and I design more around an idea. Very often these ideas are invented, so their creative value is possibly greater. However, I leave that judgment to my viewers, who are similarly divided. Spontaneity versus polish—which is more important? I try to balance these qualities, but one wins over the other a little each time.

On the other hand, my outdoor paintings are bolder, freer and more spontaneous, and are done faster. They certainly are bolder, because I have to

paint quickly before the light, weather, or other conditions change the mood of the landscape. The psychological effect of the light and sounds of nature become part of my work. When water, clouds, or weeds move, I try to imply movement. Movement can't be painted, but it's possible to suggest it better from the real scene than from a sketch or photograph, where the movement had to be stopped.

Do you work on a different scale outdoors than you do indoors?

My favorite painting scale outdoors or in, is a half sheet (15 x 22 inches—38 x 67 cm). I used to do a lot of quarter-sheet paintings outside because they're fast and I was able to bring home more ideas. But now I use a 12 x 16-inch (31 x 41 cm) cold-pressed watercolor block for this purpose. Arches makes blocks in 90-pound or 140-pound weight. I prefer the latter because it's a little heavier. I also occasionally use Fabriano 100% rag paper in blocks. In my studio I enjoy using a full sheet (22 x 30 inches—56 x 76 cm) or double-elephant size (26 x 40 inches—66 x 102 cm). I can really get my teeth into the thing and show off watercolor in all its exciting majesty.

How do you cope with the changing light outdoors?

Speed is one answer. I paint fast enough to keep ahead of the change. If there's strong sunlight, which means sharp cast shadows, I make a mark on the edge of my board (outside the painting area) to locate the sun. If the light moves too much, I just paint the shadows opposite to my light source, the sun. Another foolproof method of painting the more complicated shadow shapes is to take a black and white Polaroid shot when the shadows are in the most desirable position, and follow the photograph for the shadow design and use nature for the details.

Do you prefer any special kinds of lighting effects?

No. I like sunshine, because the shadows are interesting design elements. Lifted-out shadows in particular are fun to do. Overcast lighting is even and allows good mood and texture studies. Mist, fog, snow, and rain are ideal conditions for wet-in-wet blending. So, I like any light, and light is part of the subject I pick; usually a very important part of it.

Do you prefer to work at any particular time of day?

On a sunny day I prefer morning or late afternoon because the shadows are more interesting then. This is particularly true with more panoramic subjects, where longer distances are involved. On the other hand, I can paint live stills (to be discussed next) before, during and shortly after noon, because their charm doesn't need the help of a lot of shadows. On an overcast day, the time of day doesn't matter, because the light source is the whole sky. The light doesn't change rapidly, and the shadows show subtle variations in value, so I can do modeling within them instead of just painting them as a single-value shape, as I would cast shadow on a sunny day.

SUBJECT MATTER

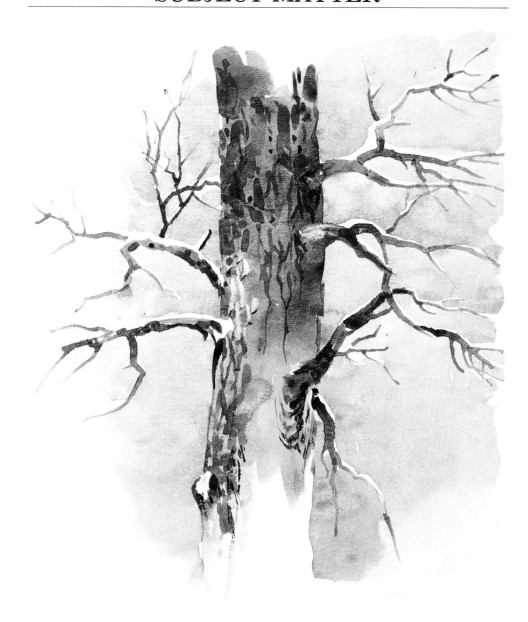

What subjects do you like to paint most?

I don't know what my favorite subjects are, but I know I look for mood. The feeling, the emotional quality, is important. To paint a tree is no longer a challenge. But to paint a *protective* tree, a *happy* tree, a *powerful* tree or a *weak* one is what I'm after. The more unusual things are, the better I like them. If I can't find mood, I use any subject and invent the mood I think it could and should have. The only real favorite of mine is not a subject, but a season: winter. Snow is white; so is paper. Watercolor has the main ingredients given before I start painting. Shapes are clearly evident and the modeling is subtle and challenging. I really love painting snow, but in general I just love to paint landscape, particularly *live stills*.

You talk about live stills. What are they?

Live still is a little word I cooked up to differentiate it from *still life*. Live stills are probably my favorite subjects. They can be anything as long as they are viewed close up: a clump of grass, little wild flowers, a cluster of

leaves, a castaway basket, anything of this nature. Live stills, however, are not tampered with; they are as I find them. A still life is set up by the artist, and the light is controlled too. But a live still is naturally lit and is undisturbed as a unit. Live stills are anywhere and everywhere. Usually I find them right at my feet, if I just bother to look down at them. Panoramic beauty is for everyone to see, but live stills are nature's hidden gifts, only for those who care to look for them and are willing to get down to earth once in a while.

Are there any subjects that you really dislike painting?

No. I've never seen anything that ugly that I couldn't paint it with enthusiasm. I don't enjoy painting the same way as everybody else. I interpret nature my way, but I can't find satisfaction painting another duck painting when there are so many artists doing them. Many of them are great. I like animals in their environment once in a while, and I like to paint people, but somehow I don't mix them together, though I've done it and I am sure that I will again. It's just that I'm awed by nature too much. When I paint people, my mind is on the figures; when I paint the landscape, I think of the land. That's something like the way it works with me.

How do you go about finding subjects to paint outdoors?

I go hunting with my brush. I don't look for specific things. I start out with an open mind, usually by driving along the road. When I see an area that responds to my mood with its mood, I stop, set up my easel, and begin. Sometimes I don't even get out of my car—for instance, in the winter—but just pull off the road and paint from my seat. I may just use my sketchbook, or do a painting, or just shoot the scene with my camera. It all depends on the circumstances. The ideal is to set up my easel on location and paint the real thing while the birds are entertaining me or the churning waters supply additional sounds. On-location painting is an absolute must for me.

Does it take long to find a subject?

There's no simple answer to this; each situation is different. Time spent has nothing to do with aesthetic values, so I'm not aware of how long I spend looking for things. If I'm anxious to paint, I stop sooner, but often I just go out to enjoy nature, and when I find "the mood," it excites me and I start painting. I very seldom go home from a painting drive without a sketch or two. Nature is simply too full of beautiful things. I'm a painter, and a painter must learn to see and not drive or walk by things like other people, whose mind is on something else. I try to see everything.

COMPOSITION

How do you arrive at a satisfactory composition?

This is like asking, "how do you go to heaven?" It's hard to say exactly what I do. I go after *balance,* using good taste and careful judgement. Composition is impossible to pigeonhole. However, some basic systems are available, for example, relating the movement in a painting to some of the letters of the alphabet, such as C, O, S, X, and L; avoiding the geometric center and the four corners; trying not to point objects or lines at the edges of the painting or to other strong shapes; avoid equal measurements, and so forth. All these basics have been organized by countless artists and rules set up; yet, here and there we find creative minds with a pioneer spirit breaking these rules one by one very successfully. Nevertheless, all artists, however daring they may be, go after *balance* in their painting in their own personal way. Composition is as personal as love. It has to feel just right.

Do you paint nature as you see it or make changes?

Composition means balance. Nature is always well balanced in the whole, but it's too big to paint. The little square-ish detail that I want to paint is never the way I want it. Again, I keep the mood, but rearrange the details to emphasize what I consider important, and play down or leave out the trivia. I like to pick a strong center of interest and subordinate everything else to complement it. I feel that composition is a personal thing, and I like my composition to be the way I decide, not the way it really is. I use the elements I find, but rearrange them into a new, more personalized balance.

How do you decide what to leave in, add, move around, or take out in order to make a successful composition?

The demand of the unit dictates it. I like to paint my center of interest as a conductor would lead an orchestra. He is the most important member, and he calls the shots. All other elements have to be in their right places and play

in harmony whenever he decides that they should. I decide how many complementary elements I need in my composition and base their location on my own judgement. The ability to make the right decision is what the game of painting is all about, and it takes a lifelong effort to improve it, even though I know full well that I, like everyone else, will never achieve perfection.

Do you prefer any particular kind of composition?

I was about to say "no," but I think I do have slight preferences—a very high or very low horizon are two of them. This way perspective can really create the illusion of depth. I also like negative and positive shapes to balance and relate pleasantly. I avoid placing major shapes or edges at the corners and the center of a painting. I also try not to just touch a shape in one plane with another shape in a different plane. And I try not to compose a shape resembling a slingshot, bull's-eye, teeter-totter, brasier, or any other mechanical-looking shape.

Do you ever use a viewfinder or other device in composing a subject?

No. I occasionally use my thumbs and index fingers to enclose a square piece of nature, but I can do it just as well mentally. Viewfinders and similar aids are a great help in the beginning. So is a reducing glass, to hold over the sketch while comparing it with nature. But these aids just become superfluous clutter in your gear as you become more experienced.

Do you have a philosophy on composition?

Yes, I plan my compositions according to a four-point system: shapes, value, color, and textures. This is a psychological order, not a time sequence. Good shape relationship is a must. Without balance of shapes, value, color, and texture are useless. Value is the tool to create the illusion of three dimensions on a two-dimensional painting surface. Color gives life to the things I paint, and with atmospheric color control (also known as *aerial perspective*) helps give the feeling of depth. Texture gives the final definition to the shapes. It describes their material surface and nature and offers variety and visual excitement. While I paint, I keep these four points in their order of importance in mind. This discipline is a good safeguard against confused paintings that would fall apart.

How do you use shapes, values, colors, and textures in composing?

The human mind can't grasp everything in a painting at a glance. Our eyes aren't capable of reporting visual images fast enough to the brain; they have to roam from the surface of one area to another in a visual travel pattern called the *path of vision*. In a well-composed painting, the path of vision is predetermined by the artist.

The ideal path of vision works like a corkscrew, moving in a circular motion toward infinity. It touches all four sides of the paper, while bypassing the four corners. My first compositional task is to determine the starting point for this visual trip.

In arranging a composition, I keep certain points in mind. For one thing, our impulsive attention is first directed to any isolated bright color or to a spot with strong contrast. If both conditions exist, the attraction is even stronger. Now, if these conditions are present in several locations in equal

strength or importance, our eyes will select the lowest one on the page first. When the composition consists of patternlike, equally important, and equally well-distributed elements, our vision will tend to enter the painting at the bottom center. Our natural tendencies will also make us look to the right first because we read from left to right, and this habit influences our tendencies. But our eyes can be directed in the above manners only if all other conditions are equal.

Can you describe the role shapes play in composition?

Of the four points I keep in mind when composing a painting—shapes, value, color, and texture—shapes play the number-one role. Repetition of shapes sets up a pattern or rhythm in a composition. But when I repeat them, I try to avoid a stiff, mechanical rhythm. Instead, I try to paint them like a melodic rhythm that complements the entire unit. I explain it to my students like this: When a child is fooling around on a piano, he may strike the same key a hundred times, over and over again, driving everybody else up the everloving wall. This is a monotonous rhythm. On the other hand, a concert pianist can also hit the same key a hundred times in playing a concerto, but the sound blends into the music and creates an exciting rhythm. We don't notice its independent existence, but just enjoy the melody as a *whole*.

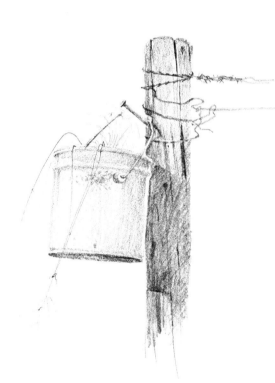

Choosing the shape of my paper, the painting surface (rectangular, square, horizontal or vertical) is the first decision I make concerning the painting to follow. This shape, called the *support shape* because it supports all the details of a particular painting, is flat and two-dimensional. So, because I work within a two-dimensional shape that must appear to have three-dimensional depth, I must think about it in three-dimensional terms, and use every trick I know to give a convincing illusion of depth.

How do you create depth in a painting?

This is where perspective comes in. Perspective is one of my friendly helpers because it allows the shapes within the painting to appear to be located in a space that has depth. Leonardo da Vinci was the first to define the law of perspective. He stated that distant objects appear paler, bluer, and less detailed than closer ones. Da Vinci was talking about color perspective or atmospheric perspective in this particular instance. But there is also linear perspective, which refers to drawing lines or shapes so that they appear to recede or advance. Like color or atmospheric perspective, linear perspective is also governed by a series of laws.

One basic law of linear perspective is that the closer the object is to the viewer, the larger it appears, and vice versa. (One of the typical errors children or primitive artists make is in instinctively placing distant elements above closer ones, instead of making them smaller.) Objects must relate to each other in scale; then must be in relative proportion to each other. For example, a man can't be bigger than the horse he's riding, and a tree can't be larger than the mountain on which it stands. But slight distortions, if they're carefully thought out, can add a creative touch and draw attention to an important detail that might have gone unnoticed if painted in the correct scale.

Do you have any special methods for recording perspective?

Just experience. I understand the laws of perspective, but when I paint, I just judge perspective by eye, and I can get close enough to correct perspective to be convincing. I keep the two vanishing points in mind while I con-

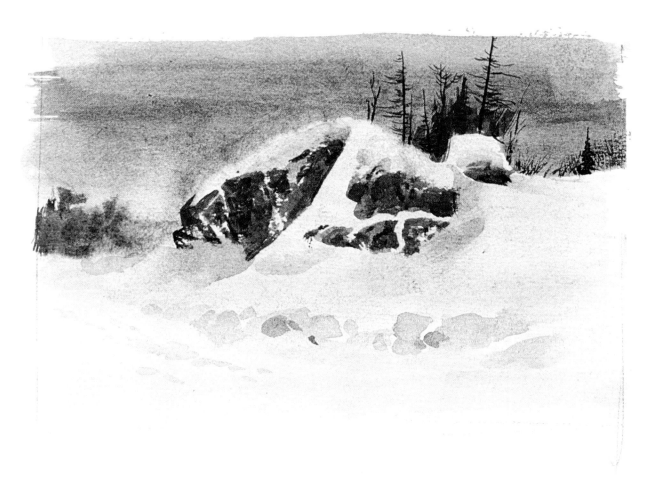

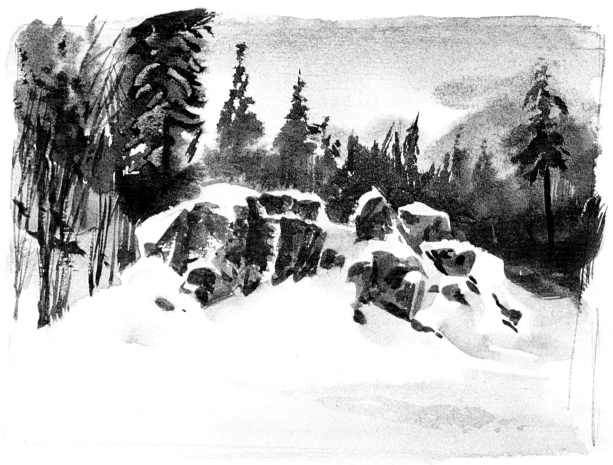

struct my painting, and above all, I try to keep my drawing consistent.

Color (aerial) perspective is as important as linear perspective. Atmospheric colors indicate atmosphere, and this means distance. Color perspective and linear perspective are two of the tools I use to show depth.

As I said earlier, the white paper is flat and two-dimensional. If you stare at it for a while, though, and your mind wants to see it as a three-dimensional plane, it will begin to look more and more like one. For example, if you draw a line across a paper from one side to the other and concentrate on it for a while, it will appear to be no longer a line but an edge where two planes meet. At first, the planes will look flat, but as you continue to stare at their junction, the line between them will seem to advance or recede and the connecting planes will feel like they're at different tilts or angles.

Changes in perspective are also created by overlapping shapes or planes. When one plane overlaps another, it appears to be in front of the other. In addition, if these overlapping planes are transparent, this may indicate movement, possibly in different directions.

Planes can also attract or repel one another. Two flat rectangular shapes, placed beside each other, don't have movement; they're neutral and feel agreeable. But if you taper them slightly in each other's direction, you'll begin to feel a tension between them. If they're strongly tapered toward each other, they'll appear to support or balance one another, but if they taper away from each other in different directions, an active imbalance, like a tug of war, occurs. You don't know which direction to look. On the other hand, if they're both tilted in the same direction, the movement will be so strong that they'll appear to be slipping out of the painting.

The placement of planes also affects the feeling of movement in a painting. Narrow planes placed close together vertically seem to resist each other, but if you turn these same planes to a horizontal position, the effect will be more calming.

Thus the interaction of planes creates excitement, prevents monotony, and allows the viewer to reach every area and detail in a composition with ease. In other words, it sets up a path of vision and creates a feeling of three dimensions. And I never allow representational details to distract from this planar interaction. I think of planes as simple shapes that just happen to have details or texture for decoration; for example, a mountain slope is a shape that only incidentally contains rocks and trees.

You have discussed the effect of line and shape on perspective. Does value and color also affect the psychological movement of planes?

Yes. When planes have different values, their relative lightness or darkness describes their distance from one another and their location in space. Dark tones generally make a plane appear to advance, while light ones make it seem to recede. However, this effect can be reversed if the planes are overlapping.

Color temperature also has an effect on the movement of planes. If you paint two connecting planes (or shapes) with graded washes, light and cool at the outer edges, and warm and dark in the center, the corners of the shapes will appear to recede. But if you reverse the colors, placing the darks on the outside, the corners will appear to advance. If you paint these two shapes with flat washes of strongly contrasting or complementary colors, the intensity will force the corners to jump back and forth with disturbing tension. I therefore carefully avoid juxtaposing these colors in compositions of a

quiet nature, but take full advantage of this effect when doing vigorously active paintings.

Our eyes also travel more easily from object to object when they're equal in shape, value, and color. This psychological trip continues not only up and down and sideways but into the distance, over established planes, and even over what appears to be level ground. It's that corkscrew action I referred to earlier: our eyes tend to skip the corners and travel in a circular pattern unless the corner (or corners) contains a distraction strong enough to interrupt this movement. For example, a strong straight line across the painting, such as the horizon, acts as an obstacle to a comfortable path of vision. Such a line or edge must be broken up by blocks of strongly crossing lines and shapes in order to keep our eye moving into or around the painting. But you can't plan the entire path of vision completely in advance. It has to grow with the composition, as the painting progresses.

Are there any general points to keep in mind when planning a path of vision?

Yes. Some lines, shapes, or edges have a natural directional power of command. For example, wedge shapes point like arrows. Curves, straight lines, and repeating shapes also direct our eye. If our attention lingers too long in any one spot, it means that too many directional pointers are aiming there. On the other hand, if our eyes wander out of the composition on one side, two or more of these directional signals are probably pointing that way.

The presence of people in a painting also effects our path of vision. For one thing, people attract attention. Also, our eyes will tend to follow the general direction or specific focus of a person's gaze, skipping other points of interest in between.

In short, the key to good composition is balance. An object with a strong visual attraction will disturb a painting's harmony unless it's countered by a complementing element or elements. The juxtaposition of many well-balanced objects induces an exciting play of tension into a painting, but bad balance creates tension in the viewer, who may walk away not really knowing why. He'll only know that he didn't like the work!

Getting back to your four-point system of composition, you mentioned that, after shapes, values are most important. Why?

Values are important in establishing the location of planes and the space between them. The local color of anything will change when it's far away because of the influence of the atmosphere, which acts like a filter. Parts of a composition in bright light will have a lighter value than those elements that are in shade. The contrast between them, either subtle or strong, gives a painting the feeling of depth. I structure my paintings on three basic values: light, medium, and dark. The in-between shades relate strongly to one of these three. My foreground, middleground, and background have to belong to one value each. I pay extra attention to the value strength of my center of interest plus the complementary values directly next to it. Other than that, I concentrate on the value of the larger shapes, which identify the bulk of each plane.

Do you paint values in any special sequence?

The safe, conventional order is to work from light to dark. Although I use this system sometimes, particularly if I work wet-in-wet, when I have a pow-

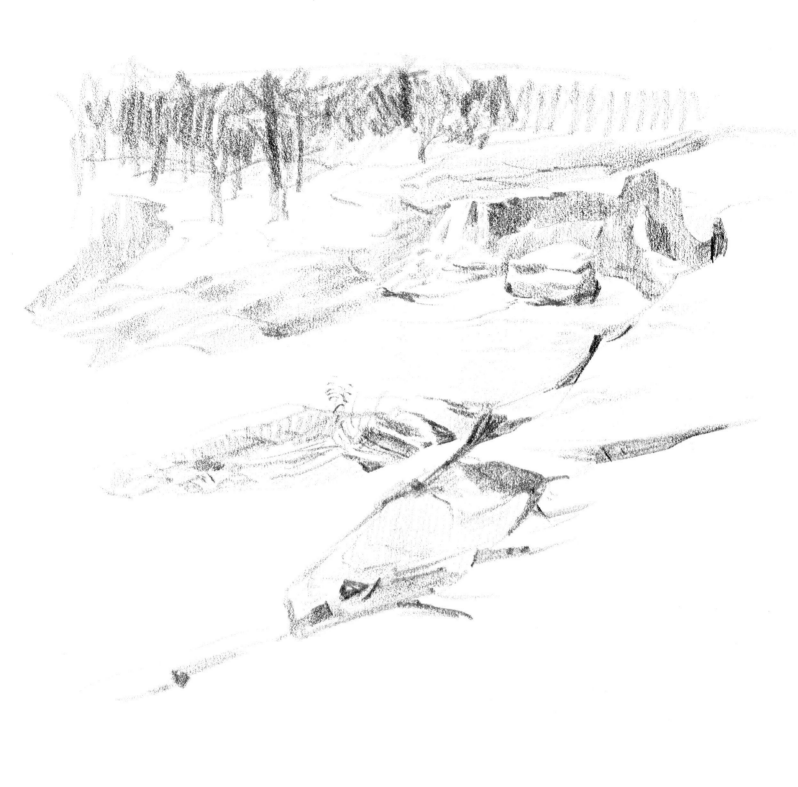

erful center of interest in mind, I prefer to start with this. I establish my most important element visually and relate the shapes and values of the other elements to it in order to enhance this focal point. I sometimes also start with the medium values and their basic shapes. By painting them first, I automatically paint around the light shapes, where the paper will stay white. Then all I have to add to this is the darks and some details, and my painting usually feels three dimensional. However, I generally don't have a set rule to do anything. Each painting is a new choice of approach.

You also talk about the importance of color in composition. Do you preplan color schemes in your head?

Very much so. I not only preplan them, but I select a palette of five or six colors maximum for each painting. These colors hold within them all the potential combinations necessary for that particular idea. I know my colors well and I can clearly visualize their individual and combined possibilities so, as I go ahead with my painting, I very seldom add to these colors. I have my mind so well tuned to this selection that I'm hardly aware of the existence of the rest of my palette.

Do you try to establish a color balance in your painting?

Yes. In fact, the preselected limited palette and the discipline of sticking with it goes a long way to insure color unity. I try not to isolate colors but distribute them interestingly. Colors with brilliant chroma look even brighter when they're placed next to neutral hues. Light and dark is more a part of the value structure than the color. Warms, because of the atmospheric influence, feel better up close and cools belong in the distance. There are exceptional conditions in nature which can vary this sequence, but I deal with them when the occasion demands it. The intensity of my colors depends upon the mood of my painting. I don't follow any absolute rule here either.

Texture is last in your four-point compositional system. How do you achieve a variety of textures in your paintings?

Texture is the spice in a painting. I like to take advantage of granulating or separating combinations of colors when I can. I also love the texture my painting knife can create, both with applied or lifted out technique. Salt, wax, and of course very frequently drybrush, are a few of my favorite tools. I really elaborated on these and many more techniques in my other three books. I use them when the occasion calls, but I don't allow any of them to be an unconditional crutch.

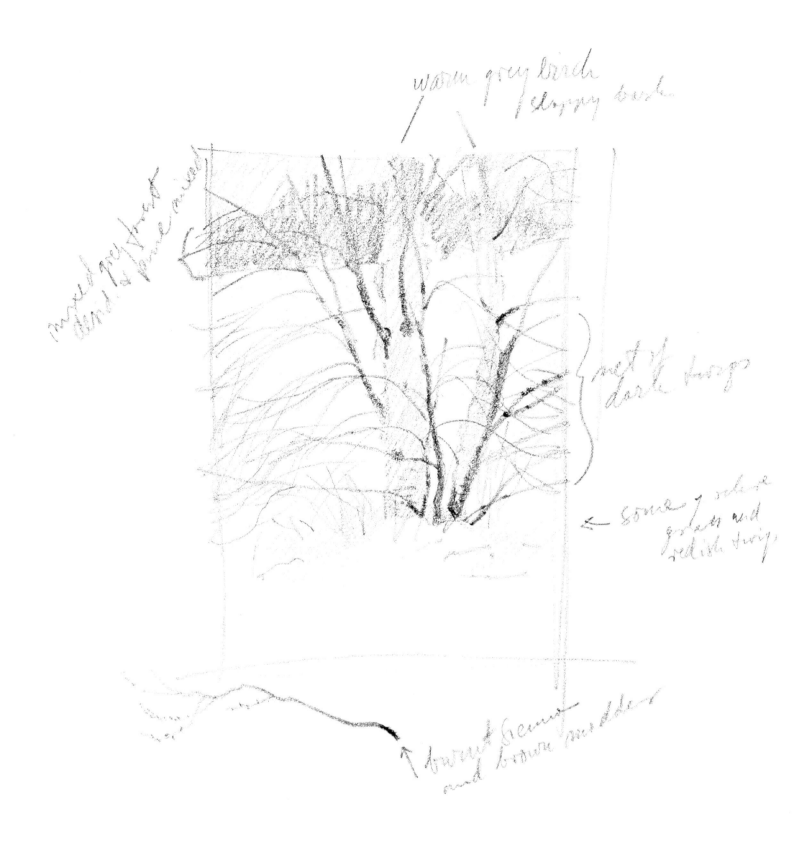

warm grey birch
stripey bark

mixed grey trunk
dark & pale wood

reddish dark twigs

← some olive
green and
reddish twigs

↑ burnt sienna
and brown madder

38

PROCEDURE

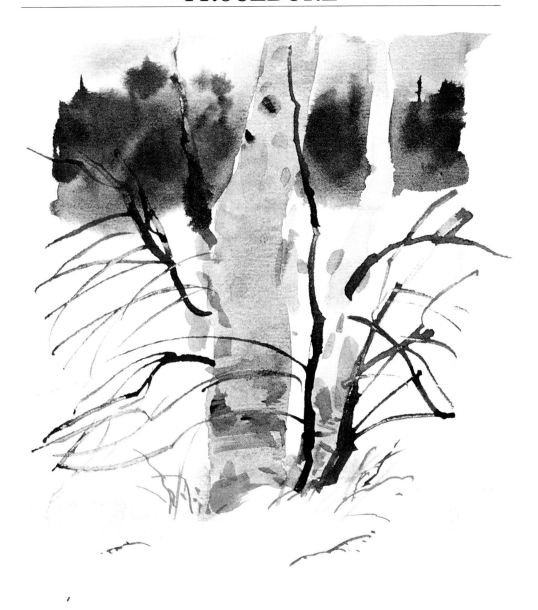

How do you start a painting?

I make a plan. If I'm not sure of the *general* composition, I do a small decision-making sketch in my sketchbook. I record shapes and values first and either paint the colors, or if I draw, I write down the names of the colors in the margins.

What medium do you use?

I like the feel of pencil, felt-tip pen, lamp black sumi ink drybrush, and watercolor. I don't know why I switch from one to another. I like the variety, I suppose. The black and white is very sensitively capable of recording shapes and values. I favor pencil or sometimes felt-tip pen for subtle things. I like lamp black ink (applied with a brush, as drybrush) for high-contrast subjects with bold shapes. On the other hand, when color is very important to register, watercolor is my choice. One of these preliminary sketches is usually

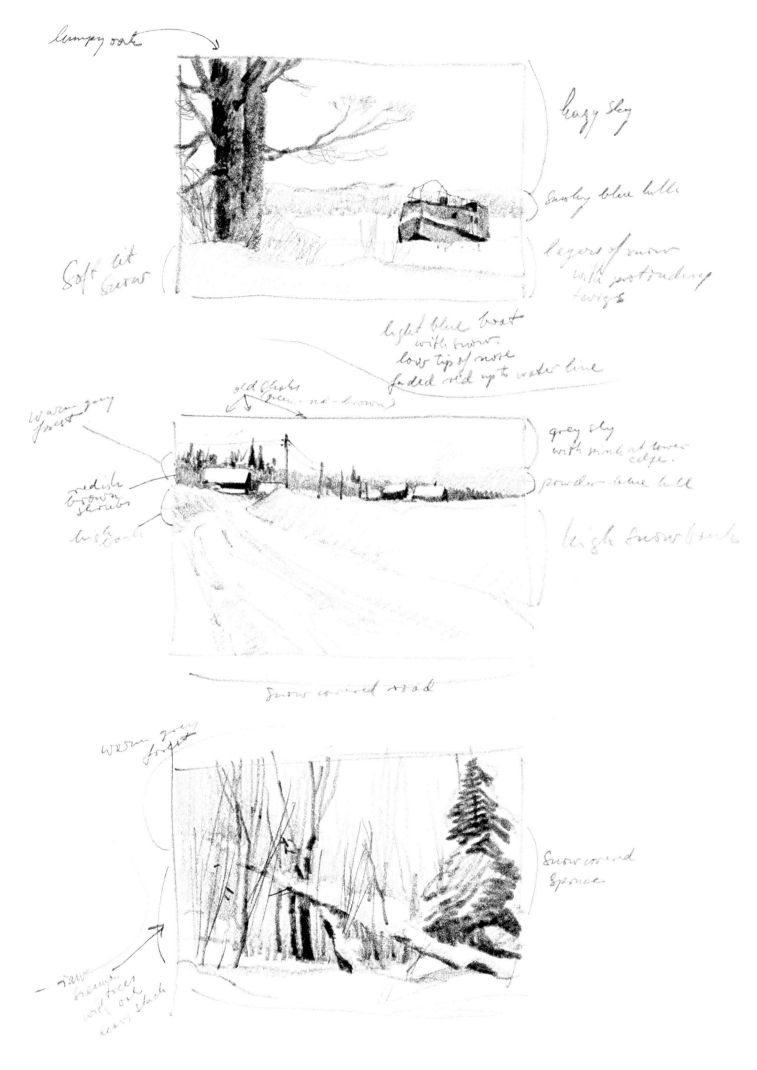

lumpy oak

hazy sky

Smoky blue hills

layers of snow
with protruding
twigs

Soft lit
snow

light blue boat
with brown.
low tip of nose
faded red up to water line

old clerks
(green-red-brown)

warm grey
forest

grey sky
with pink at lower
edge.

redish
brown
shrubs

powder blue hill

bushland

high snow banks

Snow covered road

warm grey
forest

Snow covered
spruce

raw
branches
with oak
leaves stuck

40

enough, but sometimes I need to make two or three. If the subject is not familiar to me, I do my sketch in detail. But if I'm in familiar territory, I may not even do a sketch, or I'll do just a rough one relating to shapes and value. Details belong to the finished work. I don't spend much time on sketches because I don't want to divert my emotional excitement from the actual painting itself.

Do you always make a sketch before you paint?

In the studio, I'm likely to do several sketches, each with a drastically different composition. On location, I do a sketch first only if there's a chance that the subject will change before I'm finished or when the composition is so tricky that I must plan it visually. In the latter case, the visible reality of these sketches increases my confidence in doing the larger painting, and whatever doubt I may have had at first disappears by the time I'm finished with my mini sketch.

Do you ever combine several sketches into one painting?

It depends on the individual painting. Art is a creative process, and when I paint, I try to express the feeling or emotion that occupies my intellect while I'm painting. Whether the originating influence is an experience with nature (finding a subject on location), a photograph that I took, one or several reference sketches, or just a purely creative idea doesn't make any difference. A painting has to be the product of my mind. The sketches or whatever triggered my mind into the action that eventually results in a painting are only the start. I never know how I'll start. The painting always ends up as my idea based on elements in one or another form of reference. My sketches relate to nature. I refer to the sketches in the final paintings, but change them to give me the maximum technical and compositional opportunities for an emotionally expressive personal statement.

Do you ever transfer or project your sketch onto the watercolor paper?

Project? Never! That's nothing but psychological plagiarism. I never draw on my paper at all—at least not for the past ten years, and before that only a few times. I do all my thinking in my sketches, then paint on the white paper. A pencil line isn't necessary. I draw with my brush as I paint and the free action of watercolor often suggests details. Draftsmanship is essential, but I can visualize the major composition and "imagineer" the details as I design with my brushstrokes to complement my idea.

Do you paint landscapes in the studio from memory or from photographs?

Yes, on both counts. After thirty years of painting, the old memory bank gets filled with stored experiences. This is the most important reference file I own. I work a little from memory each time I paint, and often purely from imagination. Photographs are helpful, too, particularly for capturing short-lived action; for example, ripples in water caused by a pebble or falling leaves, the last moments of an exciting sunset, or the flight of a bird. I like to use black and white photographs, and I never paint from anybody else's shot. If I use color slides or prints, I ignore the colors on them because they're never the way I like them. All color photographic processes are limited to their chemically engineered maximum potential, while my imagination is not. I prefer to use my own colors, since they're much more personal.

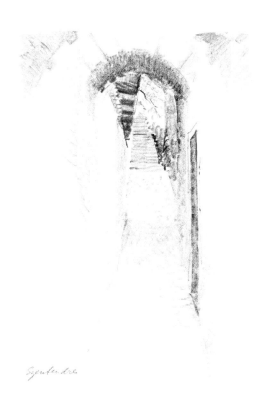

Szentendre

How do you use photographs?

I use them as I would a square little piece of nature. It is the first decision I make as far as the mood and composition of a particular painting is concerned. This is one reason why it must be my own photograph. About a third of the way into the painting, I might as well discard the photograph. I hardly use it after that. The rest of the painting is all memory work, as creative as I can make it. Sometimes I do a little sketch on a separate paper first to clarify my idea visually, but I do this only on the more complex things, and not every time.

What are the potential pitfalls of working from photographs?

I see no traps for myself any more. I was always conscious of the tendency of painters to take photographs too literally and paint everything in them. But since I've never done this from nature (I have for many years instinctively avoided the literal copy of life), I wouldn't do it from a photograph. Some painters are afraid to change a landscape and only feel comfortable photographing it with their brush. I think at best they're only good technicians, not artists. The creative part of art is to make constant decisions throughout the work, and I for one prefer to leave out everything I find unnecessary.

Do you follow any particular procedure of painting?

I like to work from area to area. While one shape is complete but wet, I go to another spot. While I work in one section, I watch the action of the drying colors in others. If they start to do something undesirable, I intervene. To be able to work this way, I trained my mind to visualize the result of the whole painting, and not to be distracted from this goal as I go on with the details. In beginning a painting, I let technical necessities dictate the sequence. Again, each painting is a new plan. I keep an open mind and use my experience to choose the best possible order to start, continue, and complete my paintings.

What role do accidents play in your paintings?

Accidents are extremely important. I count on them each time I touch the paper. Accidents are wonderful little design helpers when they happen in the right places. However, they have the impish nature of leprechans. Sometimes they start off well and turn ugly later. I constantly keep my eyes on these active wet accidents which are so rich and fresh at the end, but can't be trusted until the wash has lost its shine and is no longer active. A backrun (the wet touch on semi-dry paint) is one of these; splatter, salt, and many other techniques offer design suggestions as they happen. I love the challenge of going along with these opportunistic moments, and to make them work for me. I don't hesitate to change my approach in minor details, but I don't let these happy accidents dictate the important elements of my composition.

Do you use big brushes first, then smaller ones?

Yes. As a matter of fact, I try to use smaller brushes only for touches of detail at the end to suggest texture, or for calligraphy, or such. The reason for this order is the physical necessity of laying down the larger shapes first, which requires larger tools. I like to start with bold washes and refine them later. I use large, soft-haired brushes (1 to 3 inches—2.5 to 7.5 cm) for the first wet-in-wet delivery. Then, for the slightly better defined but still soft forms, I use a

large bristle brush (1 to 2 inches—2.5 to 5 cm). The wide, soft brushstrokes ooze further and the bristle brushmarks hold their shape better on wet paper. This is because the soft brushes hold more water and the bristle ones less water.

How do you decide how much detail to add to a painting?

Each painting requires different decisions in many areas, including the amount of detail to add. While I can't offer a fixed rule, I tend to favor treating closer elements with more definition and leaving more distant ones simpler. For example, the painting of a distant mountain will contain less detail (texture) than one of the pebbles at my feet. I also like to emphasize my center of interest with a little extra detail and play down the complementary shapes with less. The rest goes by feeling. If it feels right, I add details. But I consider simplicity a virtue, so I always leave out more than I paint in. This particularly goes for details.

Do you try to save a problem painting, or do you just start again?

If the problem is minor and it occurs where I used pigments that can be lifted out, I'll correct the trouble. However, if the error is of major proportions, I don't go any further, but just start another fresh sketch. This is usually the better approach, because the immediacy of a newly learned lesson gives me a

little extra confidence on a fresh paper. The result is the best proof. I don't like beating horses, and I never beat a dead one.

Do you ever look at a painting in a mat while you're working?

No. The dress up is "show-biz." I mat my sketch or painting at the end of the raw finish. When I've painted the excitement out of myself, my work is finished in the raw. I put my mat on and look at it anew. Usually I discover a few little spots needing improvement. A neat mat makes a painting look better by surrounding it with restful space (just as oasis in a sea of sand is more exciting than a tree in a forest).

Do you ever put a painting aside for a while before finishing it?

Of course. The more creative a painting is, the more time it takes, within reason. The thinking time has no limit. Ideas are seldom complete instantly. They grow and need molding and development. Even location work requires second, third, or more looks at home, when I'm no longer under the overwhelming influence of nature's beauty and my judgment is more objective. I truly enjoy adding the refining touches that complete the painting. It's never too late for additional clarification, but I must be absolutely convinced that it's needed, and that it won't overwork my painting.

How do you know when a painting is finished?

When I hesitate to add the next brushstroke, *I don't do it.* Instead, I put the painting down and wait, or just consider it finished. For me, a painting starts with an emotional need to express a feeling. When this feeling is spelled out technically well enough to satisfy me, I stop. Work beyond this point would be superfluous frill and clutter, and would no longer be me. Every artist knows when he's said enough emotionally. Your technique must be disciplined to stop in time. I'd much rather stop too soon than too late, so I watch for the warning signs of emotional hesitation and don't go beyond them.

Do you have any preferences for matting and framing your paintings?

Just subtle good taste. I prefer the clear warm complement of off-white neutral mats or frames. Linen or museum board are my favorites. I don't like colored mats, since they usually take away from the painting. If I use them, I only use them as a fine ⅛-inch (0.3-cm) liner. In my earlier years, I used colored mats often, particularly the darker neutrals, to bounce up a mood. In those days, all boards had acid in them. Now the paper industry has very fine all-rag boards, which I use for my final mats. I usually use two, three, or even four liners—all-rag boards cut by a master cutter for perfect sculpturing. They enhance my paintings and protect them permanently with a refined complement that's also a morale booster, truly justifying the extra expense.

What makes a painting successful?

Aesthetic quality, technically and emotionally. If it excites me when I'm physically tired after having just finished it, it means emotional success. If it looks technically as exciting or more so the next day as it did when I finished it, it's a technical success. If both, I usually have trouble parting with it, and if and when I sell it, a little of me goes with it. However, I try to keep my own excitement a personal, private experience, and enjoy the viewers' response. If they also agree, we've really got a winner.

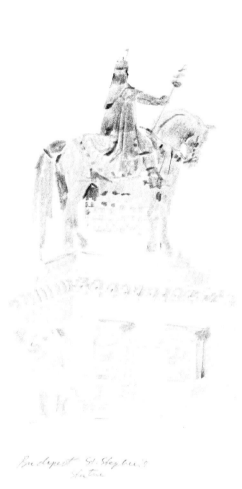

Budapest St. Stephen's Statue

GENERAL ADVICE

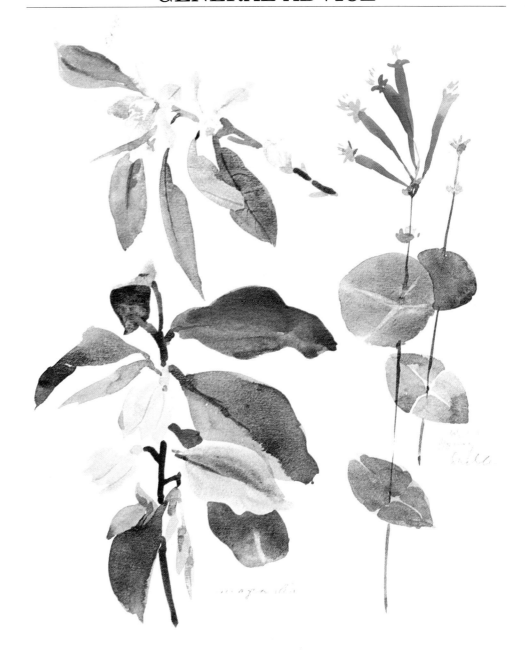

How does an artist develop a style?

Style is the result of a lot of sweat. You can't speed it up. It comes slowly and grows like the pearl in an oyster. The little creature is not even aware of the beauty of the pearl it's building; it only feels the irritation and tries to smooth out the coarse sand. Consistent, steady, and *individually* thought-out work will surely end up with a lovely pearl. The longer and harder you work, the better and bigger the gem. Learn all you can from every source, and be influenced too if you like, but *never try to copy* anyone's style. It simply can't be done, and you'd only fool yourself if you got close to it anyway. Sooner or later you'd realize the frustration of trying to be someone else and go back to being yourself again, starting where you left off. By then you'd have wasted valuable time. Style is a slowly changing experience. Throughout your lifetime, by working and being yourself, it evolves gradually. The reward, however, is worth it. Because of this growing process, it can't be copied, even technically. It's yours alone, forever.

How do you keep your work fresh and vital?

I constantly search for new ideas and technical improvements. Polishing a technique, which is my own, requires concentration. I try to make discipline my guide, to say the most with the least amount of technique possible. I don't use two brushstrokes if I can get away with one. I think and plan my procedure one brushstroke at a time. "Thinking before doing" is a simple way to put it. This discipline offers great rewards and makes constant growth and freshness possible.

What do you do to grow as an artist?

Just work. I don't believe it's possible to force growth. I try to do my best each time I paint, and when my hands quit for a while, my mind is still continuing to think about painting problems. With an alert mind, I get creative ideas at the most unexpected times and in the least likely places. However, these ideas are dormant until they land on the paper. Somehow, by working with keen interest and enjoying it all, time takes care of my growing constantly. The trick is to live long enough to be able to develop my potential. I guess this is what each artist reaches for.

How long should a watercolor take?

I certainly subscribe to the most popular answer, that of thirty years and two hours. But however catchy it sounds, this is an over-simplification. Time really shouldn't have anything to do with aesthetic quality. I like to divide the time it takes to complete a painting into two parts: working time (when I'm actually touching the paper and working on it) and thinking time (when I am developing the ideas and planning my approach). The physical work has to be quick in order for the painting to end up fresh, since watercolor dries as fast as the water can evaporate. It's during this drying period that the most exciting action-filled miracles happen to a watercolor—and happen quickly. However, the artist's experience, the complexity of the subject, and the drying conditions are the main factors that determine how long it should take to complete a watercolor. I would say that, for me, between one and a half hours to three hours is a good average painting time. However, my thinking time varies tremendously. I'm simply not aware of time while I paint. I'm too busy with my idea and too involved with the technique to be aware of anything else, least of all time.

Why do you paint in watercolor instead of any other media?

It's more fun. Watercolor is active even after I've lifted my brush. The challenge of painting with watercolor is like that of controlling a rambunctious colt. I have to show it who is the master. At times, it tries to help me; other times it fights me. The action of the flowing wet paint is an exciting reward each time I paint. Other major media simply don't do this. Another reason is permanence. Watercolor is the oldest and most permanent *proven* painting medium. I use the best paper and the best paint, so the lasting quality is beyond question. My only concern is that my work be as aesthetically worthy of lasting as the ancient watercolors have been.

Why do you prefer transparent watercolor?

Although its transparency is difficult to control, watercolor is the media that offers the greatest flexibility. First, by simply diluting the paint with clean

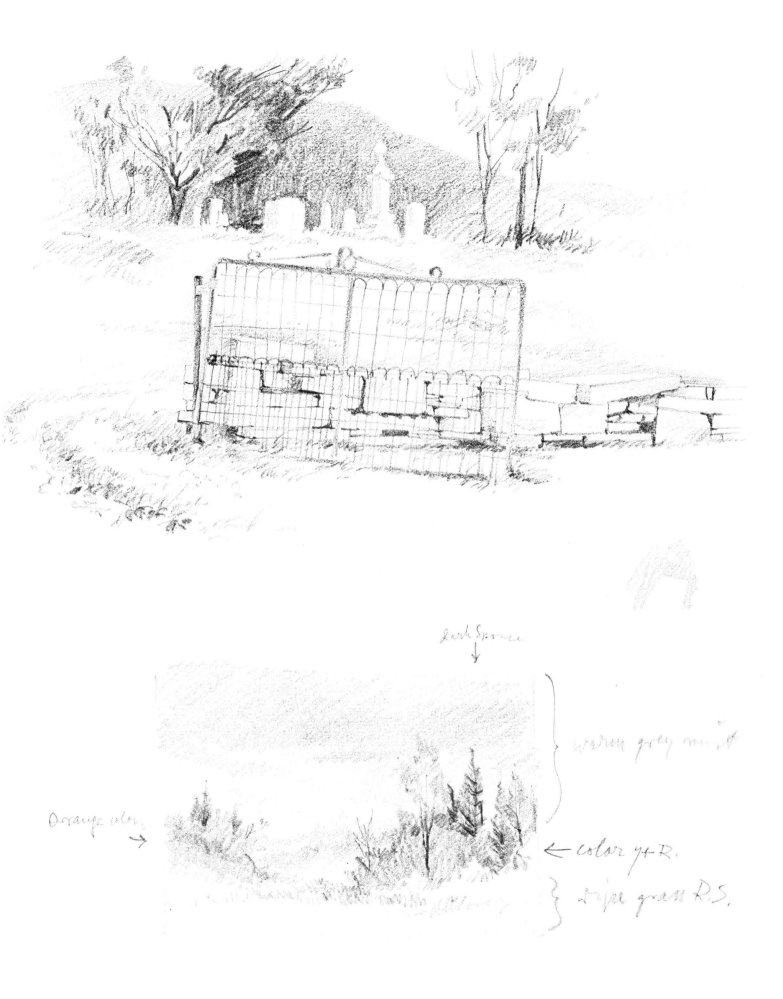

dark Spruce
↓

warm grey mist

Orange color
→

← color y + R.

} ripe grass R.S.

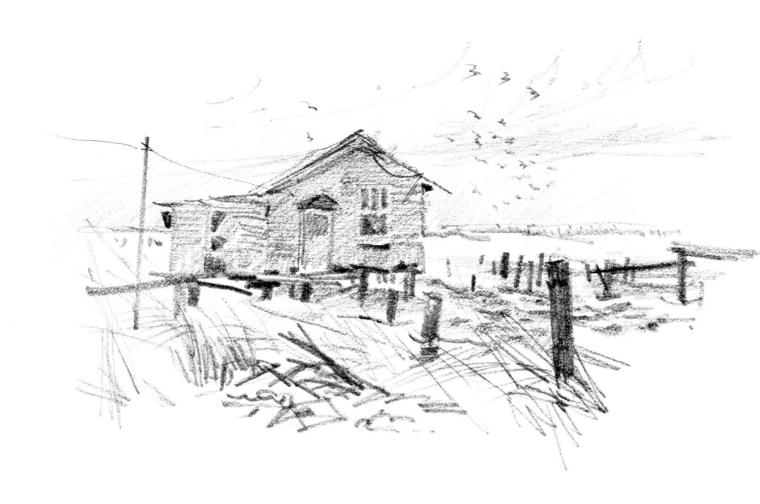

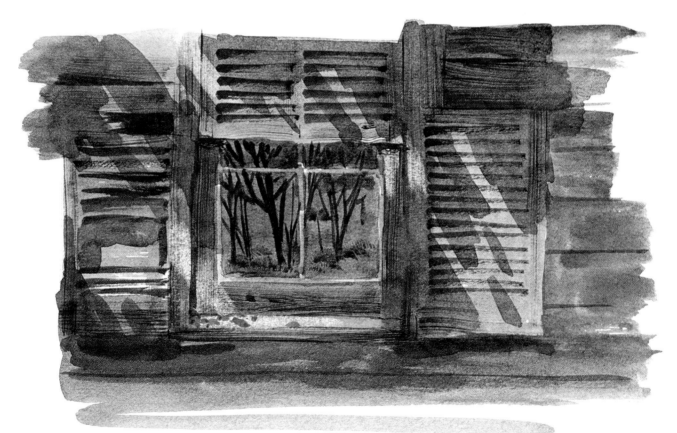

water, you can get an exciting glow of colors. Then, because watercolor can be redissolved when dry, it also has the potential for recovered luminosity. That is, you can lift out darker values from a wet or dry wash in order to regain the brilliant transparent light colors that lie beneath them. The transparency of watercolor also allows the white paper to shine through behind the color, brightening colors without adding white paint, which would dull them. Also, the action and speed required in doing a watercolor gives the media a temperament that I love. It doesn't just sit where I put it, it fights back a little. It demands respect and concentration, like a chess game. One wrong move and I lose the game. Because the possibility of losing always hangs over my head like the sword of Damocles, winning is that much sweeter.

Do you ever use opaque watercolors or acrylics?

As a designer in commercial work, I used to work with designers' colors and acrylics, and I must confess, I gained good skill with them. After all, I used them every day. However, because of those years of commercial application of these mediums, I still associate them psychologically with the limitations of commercial work. On the other hand, I enjoy unlimited freedom with transparent watercolor because I associate it with my "free-as-a-bird" painting emotions. I also prefer another media—casein tempera, for the same reason: I learned to use it for fun, and the result is more creative.

Do you ever combine them with transparent watercolors?

I never combine other media with transparent watercolor in my paintings. However, I love playing with all kinds of mixed media in my sketchbooks or on-the-spot doodles, where speed is essential. My studio doodles for paintings in the planning process may be done in any media. These are reference sketches, and I don't care how I get my ideas down as long as I get a visual image. After all, I wrote a book on this subject, *Creative Watercolor Techniques*. These mixed techniques loosen me up and prevent me from getting tight, but they can't replace my first love, transparent watercolor. All the while I'm using these mixed techniques, my mind is constantly thinking about how I'll approach these subjects in the final painting with pure transparency.

What is your philosophy on art?

It's a long list of principles. First of all, I feel obliged to be myself, completely and absolutely, to the best of my ability. My idea is presented my own way each time. I owe this to my viewers, whom I respect, and of course, I owe it to myself. I attempt to communicate my ideas and emotions through the painting itself, and try to infect my viewers with them.

I do my best on each painting, but as I get better through the years, I don't excuse my older work, which by then will be inferior. At the time when I painted them, they were the best I could do. My conscience is always clear. The value of an artist's work gets higher as he gets better, and mine is no exception.

I don't believe in "artistic temperament." Temper tantrums are no more excusable for artists than for anyone else. The rewards of social acceptance are no excuse for ill temper or rudeness. On the contrary, because of the necessity of public communication, an artist must learn to discipline himself

socially if he expects his public to believe that his creations are truly representative of himself.

Would you have suggestions about ethics?

Ethical behavior starts with unconditional honesty in an artist's work. I try to mold whatever influence is affecting my creative growth to blend with my thinking and technique. During the student years, copying is necessary for learning purposes only. Student copies are usually only as valuable as the amount of knowledge resulting from them. I consider it wrong and unethical to sign them.

Because of the eventual necessity for an artist to do business with the buying public, good taste and fairness both ways is a good guideline. It certainly is for me. But sometimes misunderstandings (usually innocent) occur. For example, buyers may ask me to copy my own or someone else's work for a commission. The temptation, of course, is money. But in this and similar situations I explain, calmly and without accusation, that I don't do it, and a better understanding usually results. I don't allow myself to be tempted by the temporary success of other artists where it is based on poor ethics. Instead, I try to listen to my own conscience and do to others as I really would like them to do to me.

Are there any artists you particularly admire?

Of course, there are many. I don't think I should mention names, but I love to look at good paintings, particularly good watercolors. They all leave a little impression and serve as proof that each plateau of standard can be surpassed, so I can aim high enough to best my own highest standards and break my own records. Other artists supply thoughts to the creative process like food offers relief to hunger. Being a social creature, like my fellow man, I relate to others' work, but I try to limit my influences to the level of my intellect. I wouldn't copy or try to copy their ideas or technique. I think my originality is a sacred responsibility that I enjoy and demand from myself. Sharing a creative kinship with others is an exhilarating experience. I try to keep it from going any further than that.

What are the rewards of being an artist?

For me, there are many. To be able to communicate my ideas and feelings to others is the real driving force behind my life as an artist. To see the expression on faces that say something like, "I understand what you meant when you painted this" is more important than if they say that they like it. This positive response is addictive. Other rewards also enrich my life, like teaching and helping others grow, being able to observe a few more secrets of nature than unaware bystanders. Monetary rewards are also contributors to a good present and future, but money is last in order of importance. Spiritual and intellectual awareness is probably the first.

What are the drawbacks in being an artist?

For me personally, not having as much time to spend with my family and friends as I'd like is one drawback, though people in other professions may have even less time. I'm lucky, though. My wife Linda is also an artist and has her own need for self-expression, and so understands mine. Another drawback for artists in general may lie in their own nature. Some artists are

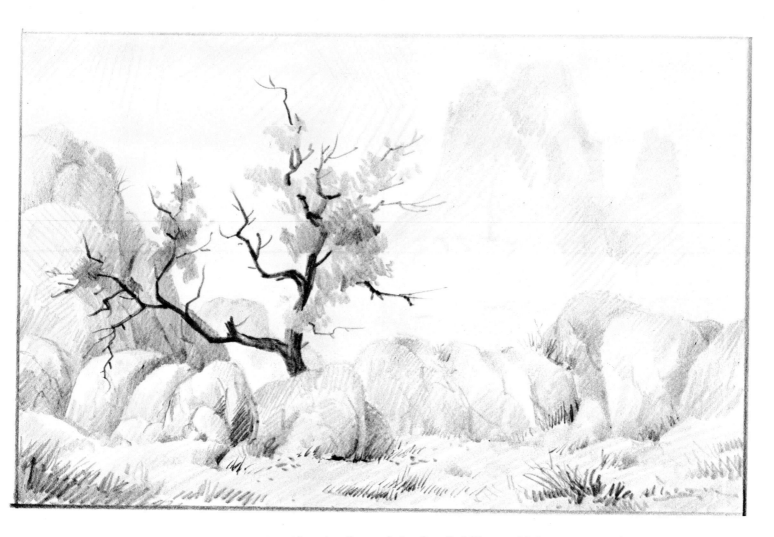

trusting to the point of gullability, which may occasionally make them vulnerable to people with questionable motives. There's also the pressures society creates to make money from art, which may choke creativity and tempt an artist to violate his integrity. It may be hard to turn down a fat commission, for example, to paint a relative in her pink hat with a bumble bee on top, or to flatter a politician by painting his portrait from an old photograph where he was much younger, or giving him hair when he's bald, or leaving off his glasses. These traps are real and dangerous, whether they come from a relative, a friend, or a president. An artist's integrity must be above reproach. Every business has its temptations, and like other professionals, artists must know when to accept and when to refuse commissions.

Do you have any special plans for the future?

I intend to do justice to my principles and share my ideas with society. I hope that my work will contribute in some way to the culture of my adopted countries, Canada and the United States, and will further the development of watercolor as a major media, or one at least equal to all the others. I certainly hope to do a little teaching and writing, but first and foremost, I want to be known as a painter. Writing and teaching aren't worth anything if I can't do it with a brush. Painting is my life and I must give it all I've got. I owe it to Linda, the rest of my family, and most important of all to my Creator who entrusted me with such a rewarding life. What more can I say? Keep on painting.

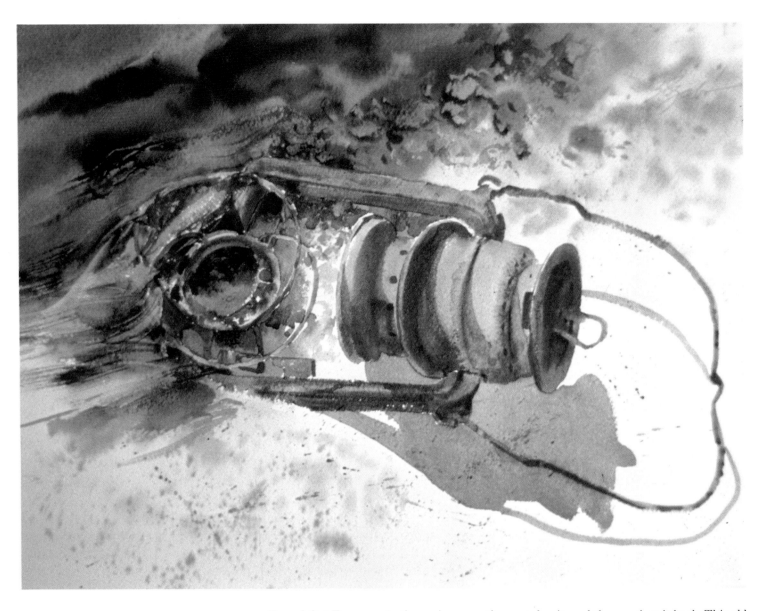

Tossed-Out Treasure. As the saying goes, the sea takes it, and the sea gives it back. This old lantern was tossed to shore by the tide in St. Andrews, New Brunswick, Canada. By using fresh glazes of transparent colors and by carefully selecting my values, I make one shape stand out in front of another. The different textures describe their material nature. I began the twisted old lamp on white paper with a mingled combination of burnt sienna, French ultramarine blue, some sepia, and, most important, the rusty color of burnt sienna, which predominated. I painted the still-wet seaweeds with sap green, sepia, and French ultramarine blue. I touched up the edges of the pebbles and added some light lines in the dark mass of green weeds with my palette knife. I wet the paper and splattered some texture into the sandy white shore. Finally, I painted the complex cast shadow of the lantern with sepia and French ultramarine blue as a single tone, indicating a continuous shape.

Step-by-Step Demonstrations

Diffused Winter Light
WET-IN-WET

This is a winter landscape, done in neutral tones, of a dreamy subject. The typical warm gray overcast sky that precedes a quiet snowfall tends to warm up the colors of the landscape. Even the snow, which we normally think of as being blue because the blue of the sky is usually reflected down on it, has a warm quality here because the sky is warm-colored. I decide to paint this landscape wet-in-wet because it offers the advantages of subtlety and softness. With this softness in mind, I also select my palette, choosing five colors: three warms (raw sienna, burnt sienna, and brown madder), which dominate, and two cools (Antwerp blue and French ultramarine blue), which complement them.

PRELIMINARY SKETCH

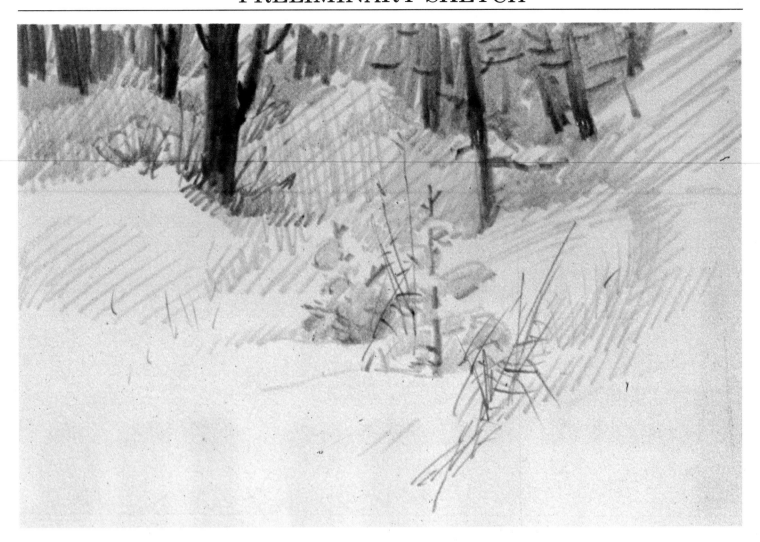

I start by wetting the paper completely. I establish the mood of my painting first by adding neutral and warm gray washes of light to medium value. I work darker in the distance and fade them slightly as they advance until they're lightest in the foreground, hinting at some modeling in the middleground by not applying my light gray wash too evenly. I allow the brush to release varying amounts of paint in each brushful, suggesting difference of elevation in the snow. (Later I plan to paint stronger images, such as trees and weeds, into these areas.)

Next I paint the sketchy elements of the distant forest, letting the cool color of some evergreens contrast against the warm opening in the sky that hints of sunshine above the clouds. By adding just a little more detail and warming my colors slightly as I work toward the foreground, the gray, deciduous forest appears to advance. The nearby trees are strongly defined with crisp drybrush touches of French ultramarine blue and burnt sienna at their snow-covered bases. Then, I knife out the texture of the trunks from the rich, still damp pigment by gradually releasing pressure on the knife. This exposes the strong stain of burnt sienna, which is the dominant color. I call this technique "recovered luminosity." By scraping or lifting out dark colors to expose a lighter staining color below, the luminous color gives the effect of light being reflected from the white snow into the dark side of the tree trunks. (For more information on specific techniques, see *Zoltan Szabo Paints Landscapes.*)

Detail. I drybrush the tree trunks on the unevenly drying paper. Where the brushstrokes touch a wet area, they soften and blend; where the paper is dry, the edges stay sharp. Note the luminous effect I get by knifing out color.

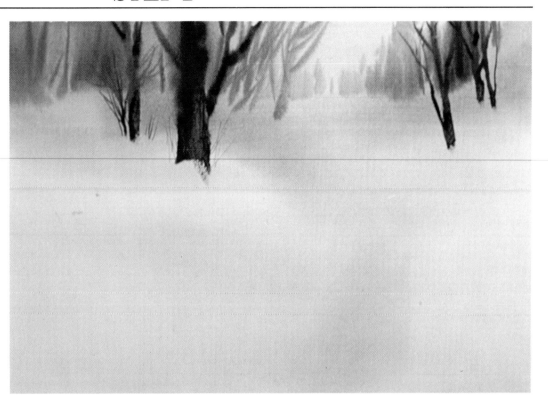

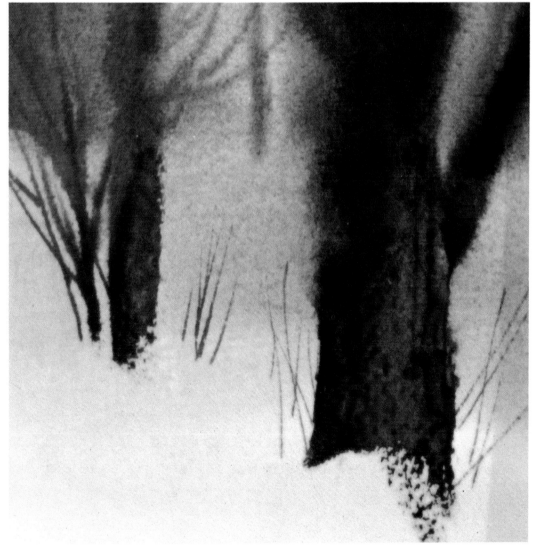

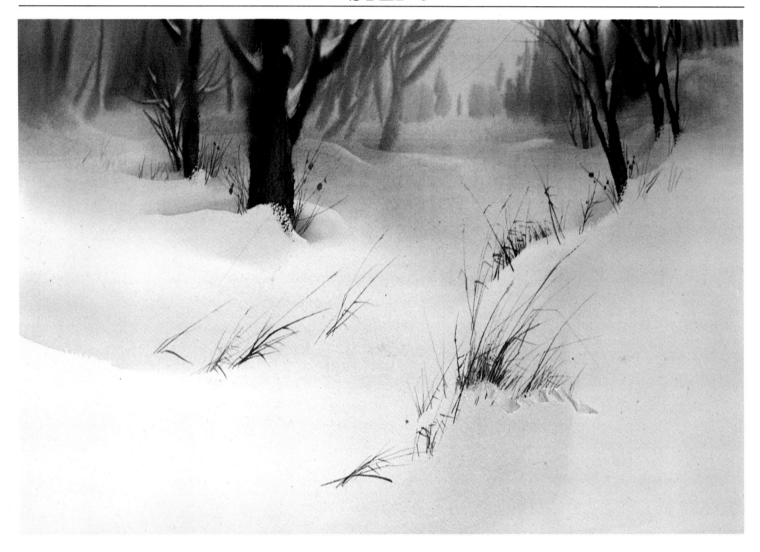

Hidden Creek. Finally, I glaze on some subtle values for mounds and dimples in the snow, further developing the rolling nature of the middleground. I am still using French ultramarine blue and burnt sienna, with a tiny addition of Antwerp blue. I add a few small twigs and dry weeds to carry the dark, warm color into the foreground and define the patches of snow on them.

The finished study is full of the subtleties I wanted to capture. The contrast between cool and warm color is limited to the distance and hints of oncoming sunlight, adding another mood to the painting. The clusters of weeds in the foreground subtly lead into the wet snowy area, the hidden creek. The calligraphic brushstrokes I use complement the soft wet-in-wet technique of the snow, without the transition between them being too obvious.

Detail. To form the lost-and-found edges of these brushstrokes, I work on dry paper. Leaving one edge of the brushstroke sharp, I softly blend the other edge into the white paper with a thirsty wet brush. (To do this, I wet the brush with clean water and squeeze the water from it with my thumb and index finger; the brush will now draw the excess water from the paper.)

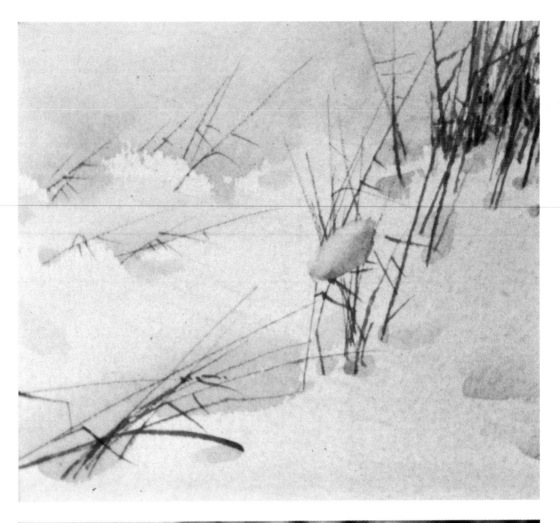

Detail. At the same time that I model the snow, I wet-lift out a few highlights from the clumps of snow in the grass and on the heavier branches of the trees to complement the lost-and-found edges of the brushstrokes in the preceding detail.

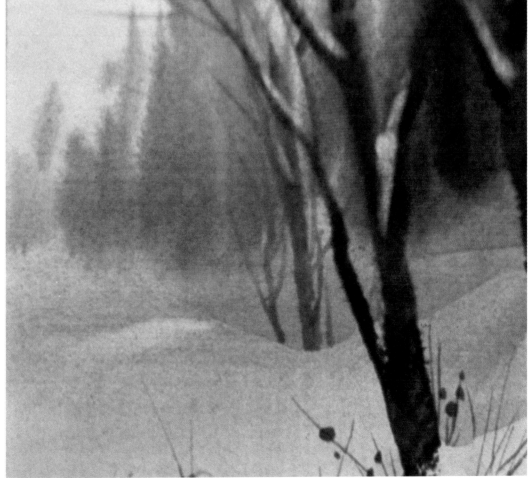

Shadows on Snow
GRANULATING WASHES
AND LIFTING OUT

In this painting of a snowy scene, I take advantage of the sedimentary and lifting qualities of manganese blue when used by itself or mixed with another color. Had I painted the subtle details into the even shadow washes instead of lifting them out, I would have found it more difficult to control them. But by lifting them out after the paper has dried, I can be much more accurate because I have unlimited time to think out every brushstroke. My palette is manganese blue, Antwerp blue, and French ultramarine blue on the cool side, and raw sienna and burnt sienna on the warm side.

Starting on wet paper, I apply varied values of a shadow color made up of manganese blue, French ultramarine blue, and Antwerp blue, with a little burnt sienna. I also hint at the distant weeds, blurred slightly out of focus, with various combinations of raw sienna, burnt sienna, manganese blue, and French ultamarine blue. The shadows cast over the tire tracks by a picket fence provide me with the opportunity to design exciting shapes. I deliberately make my shadow wash light so it can be lifted off more easily, leaving the pure, almost white color. I model the darks and medium darks in the shaded areas in order to show differences in ground elevation through varied values of a shadow color made up of manganese blue show differences in ground elevation through varied reflected lights in the shadow. I want to make the little hoarfrost-covered weeds very important despite their innate subtlety.

Detail. While the color of the distant weeds is still wet, I lift out some of the hoarfrost-covered weeds and introduced light values into a predominantly dark area with a small, clean, thirsty bristle brush.

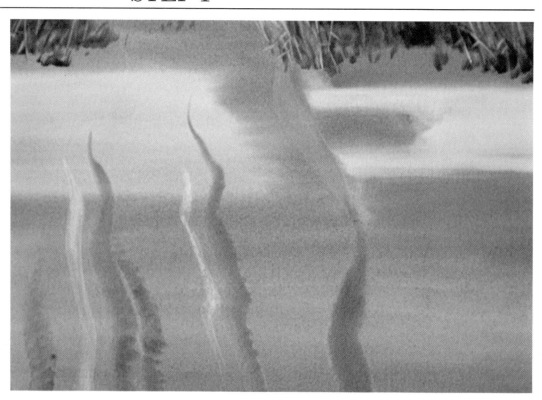

STEP 2

Next I lift out the shape of the sharp, brightly lit hoarfrost-covered weeds in the middleground, removing as much color as possible. Then I paint the warm color of the base of the weeds into this glowing negative shape. I also paint the shadow these weeds cast in the snow and lift out the sun-filled areas between the shadows of the weeds and the picket fence. As I lift out the shadow color, exposing the sunlit snow around the shadow shapes, enough color remains to give the snow some value and sparkle.

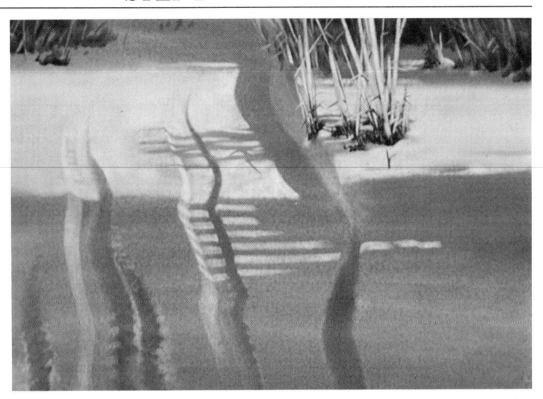

Detail. Because the frost on the weeds is in strong sunlight, I scrub off all the color from the background area that they cover. Then I work the warmly lit base structure of the weeds into these thin shapes.

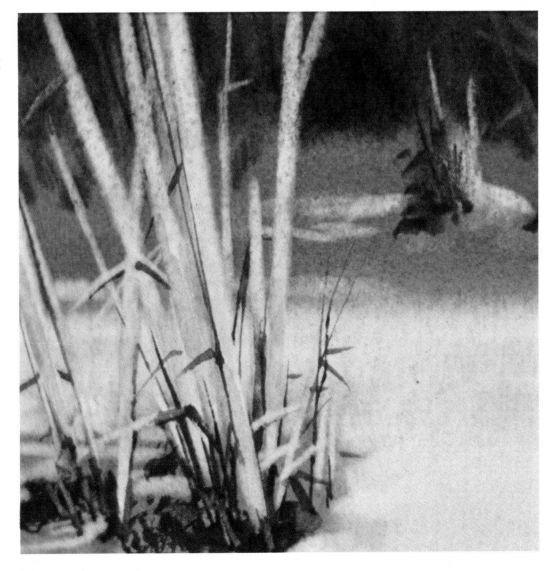

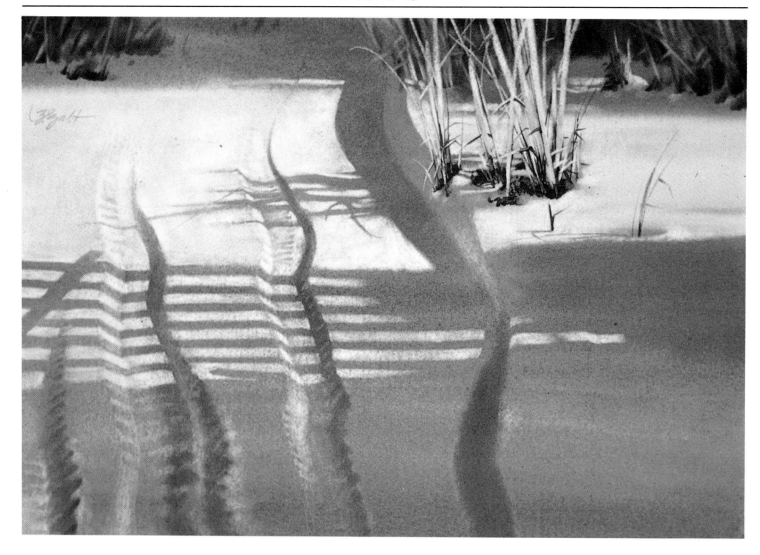

Snow Fence. Adding the details in the shadows comes last. The values within the cast shadows on the snow and the reflected light on the slopes of the tracks vary according to the strength of the light. The tire tracks complement the perpendicular images of the ice-frosted weeds, repeating their dynamic curving lines and shapes, and contrast with the crisscrossing, horizontal fence shadows. The lines balance each other, creating a quiet, solitary mood.

Detail. I place delicate details at the center of interest, where extra attention is required. Note the variation in the amount of color I lift out for the middleground weeds in the center of interest, which are struck by more sun than the background weeds, where there is less contrast.

Detail. I am extremely satisfied at having painted the shadow shapes in a single wash. The sparkle in the shadows in the snow is caused by the grains of manganese blue, which separate from the other colors in the wash.

I based this demonstration on a drawing in my sketchbook of a creek bed with stones exposed under the water. In the scene, a little ice on the water's edge created a contrast in value with the snow and weeds, drawing attention to the underwater detail. My palette is sepia, raw sienna, burnt sienna, Antwerp blue, and French ultramarine blue.

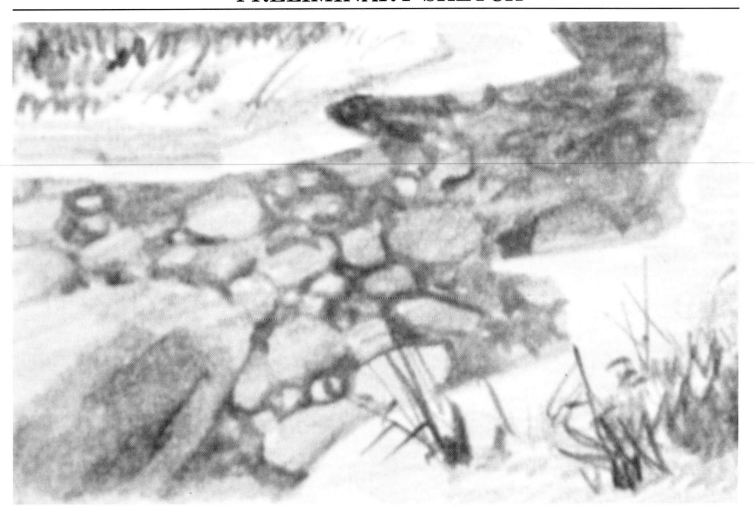

First I establish the approximate shape of the water area with a very light wash of sepia, just enough to act as a guide to where the ice stops and the riverbed begins.

I tape out the icy edges around the riverbed with masking tape. Then I paint the rocks and pebbles with a drybrush technique, using a thick application of sepia in the foreground, thinning and lightening it slightly as I move into the background. I underpaint the texture on all the pebbles in this loosely painted manner, making sure that the sepia stain is sufficiently dark to survive the light scrubbing I plan to give it later when I lift out the ripples on the water covering the pebbles.

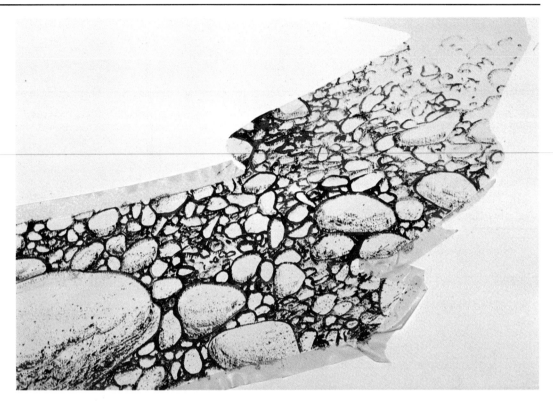

Detail. The masking tape, which protects the drybrushed edges where the pebbles touch the icy river bed, is still on the paper. I also splatter a little sepia on the near side of the larger rocks in the foreground for added texture.

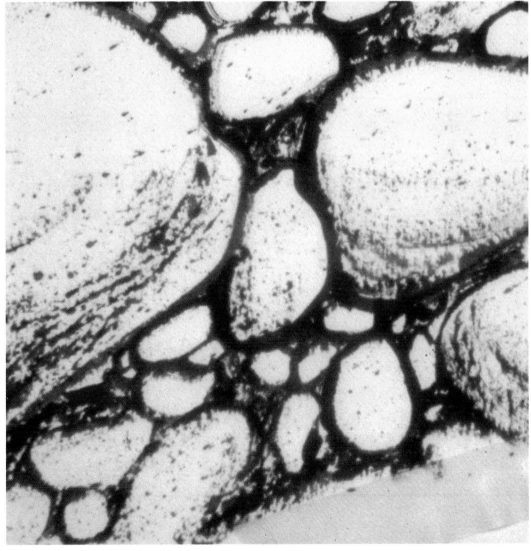

I remove the tape and paint the ice on the left-hand bank with several extremely light glazes of raw sienna, Antwerp blue, and French ultramarine blue, with the Antwerp blue dominating the wash. I also add a bit of salt at the lower left center, near the water, to give a frozen texture to the ice. Then I paint the clumps of dry weeds into the snow on the left bank.

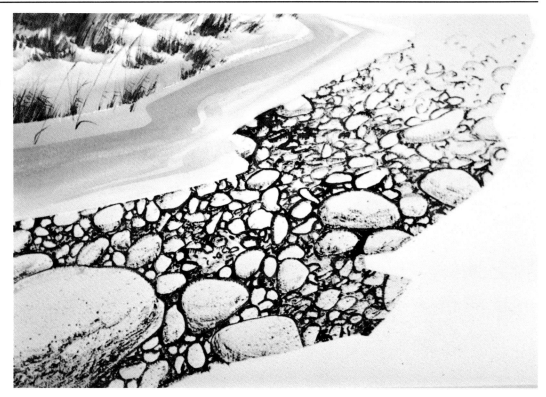

Detail. French ultramarine blue tones tend to dominate the color of the snow here, but the combination of colors still remains the same. The dry weeds were drybrushed on and then knifed out. The occasional individual leaf received special attention.

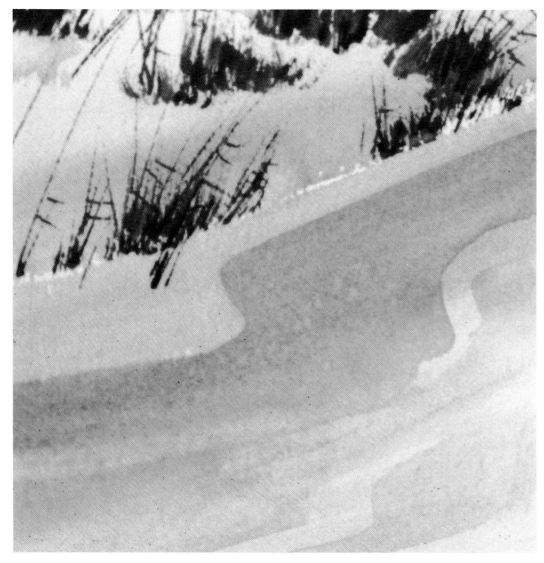

Working on top of the drybrush-textured creek bed, I glaze on a strong, medium-value wash of raw sienna, burnt sienna, and French ultramarine blue to represent the dark, warm color of the water. I continue to glaze on the pattern of the ice and the subtle hollows of deep snow covering the bank. I also add a few more clumps of weeds, as I did in the preceding step.

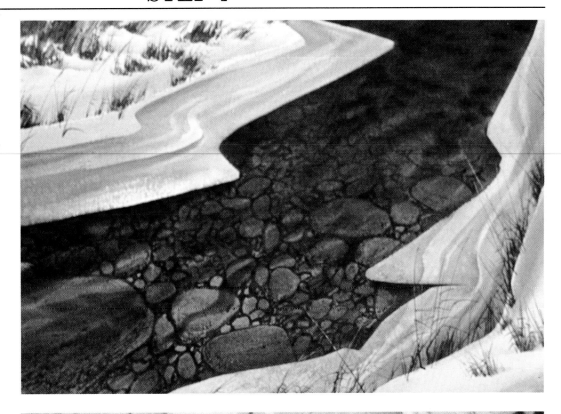

Detail. The glazed-on ice pattern not only hints at the direction of the waterflow, but it also contrasts sharply in color, value, and texture with the soft snow next to it. The delicate weeds on the slope of the bank also help to give the illusion of depth.

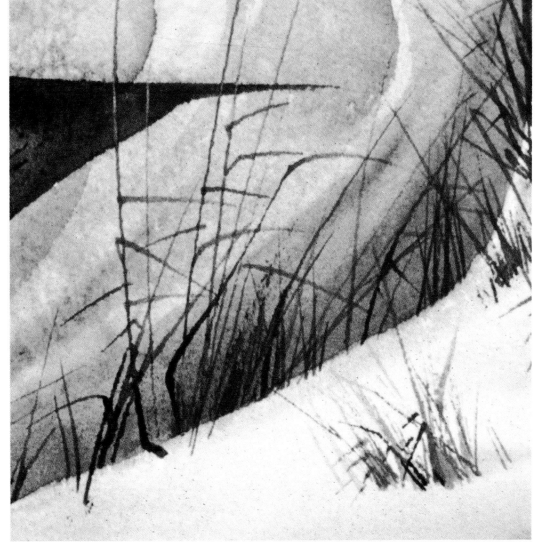

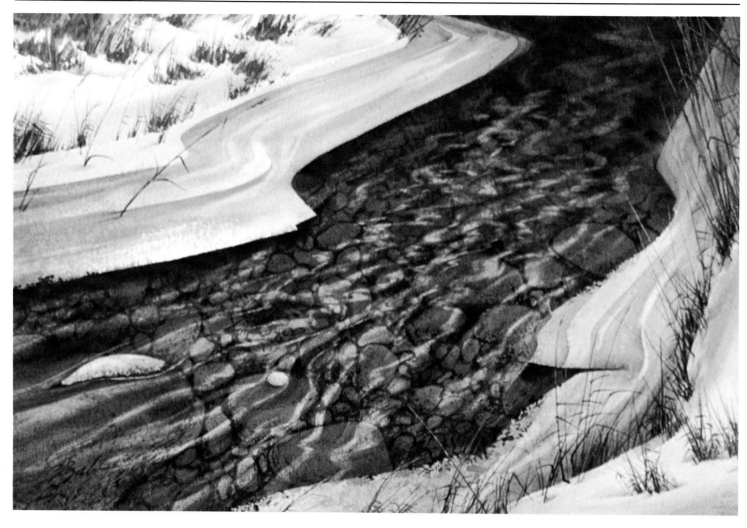

Northern Runner. I paint warm color on a few edges of the ice to cut down their harshness and to give a swift direction to the water flowing over the ice. I use a wide, 1-inch (2.5-cm) soft brush and glaze on one layer at a time in very light values of raw sienna, Antwerp blue, and French ultramarine blue. I also continue to lift out the reflections of light in the water. In fact, the lifted-out reflection is what makes this study seem complex. Note how the foreground area is tied to the background through the warm color spots of the weeds.

Detail. By glazing warm strokes of color on the distant ice, I relate it to the color of the flowing creek below it. My rhythmical brushstrokes also echo the flow of the light-struck ripples I just lifted out.

Detail. I use both a bristle brush and a no. 6 sable pointed brush to lift out the ripples on the water. Where the form is sharper, I take more care to keep the edge I lift out sharp and contrasting. Where the edge is soft, I use more water and apply less pressure to the brush.

Mist and Ground Fog
WET-IN-WET AND DRYBRUSH

This demonstration painting is an exercise in painting a misty scene. In this case, unevenly distributed patches of ground fog move in and around objects in the landscape. The colors I use in this painting are raw sienna, burnt sienna, new gamboge, cerulean blue, French ultramarine blue, and Antwerp blue.

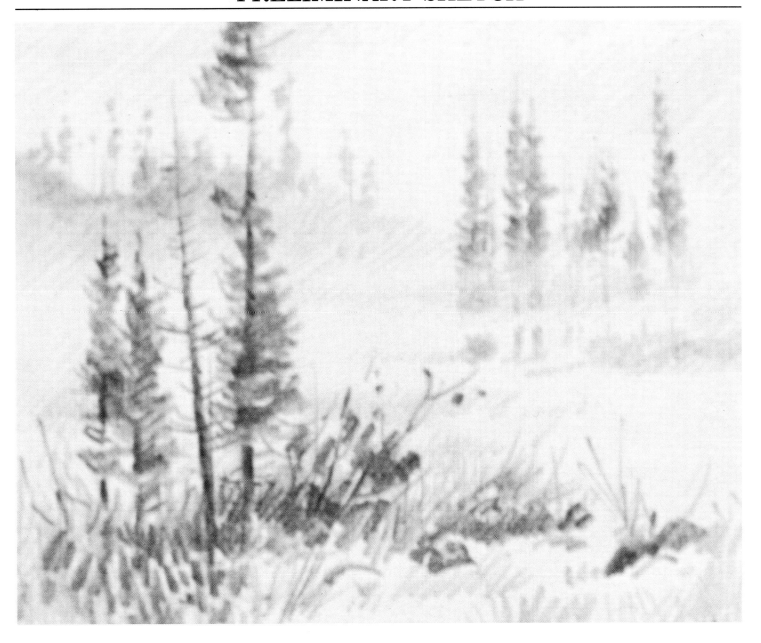

Working wet-in-wet, I soak the paper thoroughly and establish the fog pattern and, at the same time, the most distant rim of the hill on the wet paper. I use a little raw sienna in the mist as a warm touch, hinting that the sun is not far from bursting through. To paint the distant hill I use raw sienna, burnt sienna, French ultramarine blue, and a touch of cerulean blue.

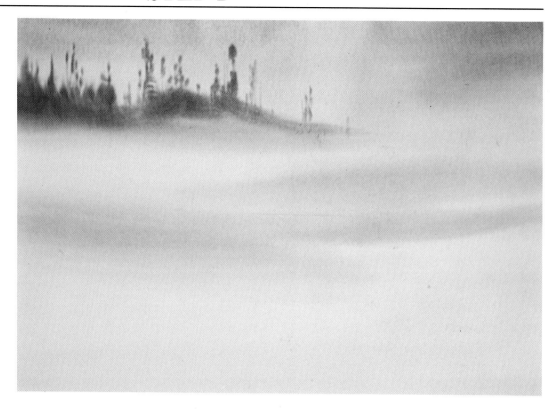

Detail. The softly contrasting washes on the wet paper contain more paint in the darker strokes and more water in the lighter ones. In painting the misty trees, I use a bristle brush and very little water.

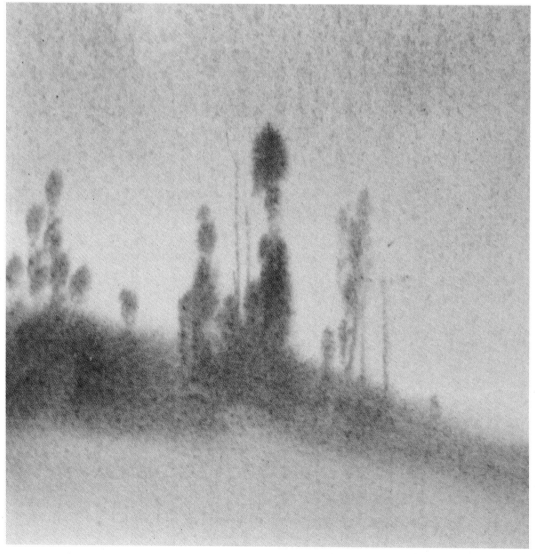

I paint the middleground trees with the same color combination, but in a stronger value and with a little more definition. The paper is gradually drying and by now some of the trees are painted on dry paper.

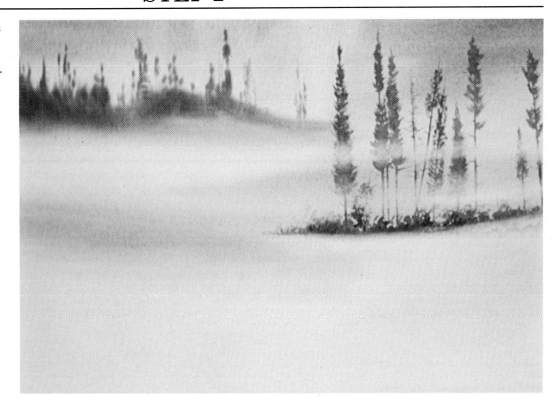

Detail. The background trees actually remain warmer than those in the middleground because of the yellowish glow from the sky, which affects the local color of these trees in spite of their distance from the viewer. In definition, however, they still remain soft.

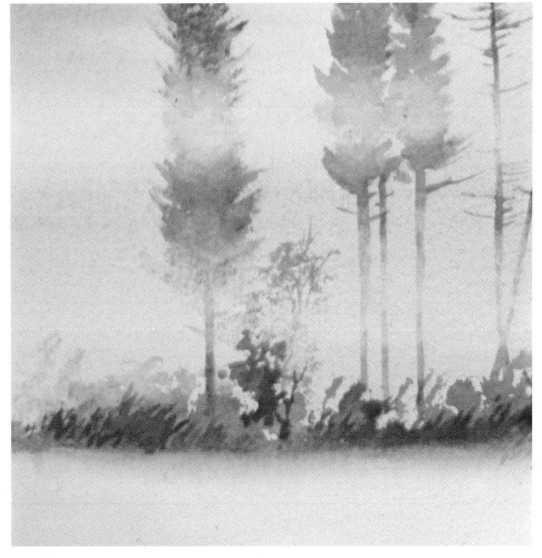

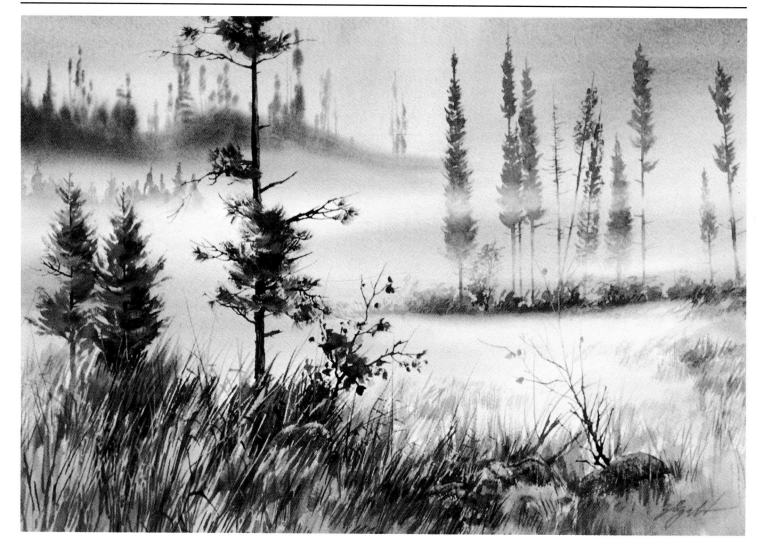

Lifting Mist. I paint the foreground last, taking extra care to get the correct value and color. The colors here are warmer, details are sharper, and wherever the images are silhouetted against the misty background, their value is a little darker.

Detail. There is a slight interplay of values in the drybrushed pine tree branches. The woody twigs are carefully designed and positioned and the little clumps of pine needles at their tips are well defined. All in all, the fine details in the foreground, with their increased definition, warmer colors, and deeper values advance in perspective. In contrast, the softer background forms established earlier recede.

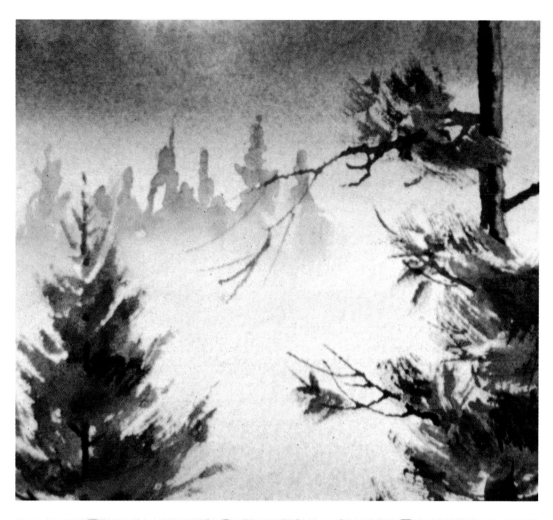

Detail. I start painting the foreground grass with drybrushed strokes of raw sienna, burnt sienna, and a little Antwerp blue. I use a bristle brush. When its firm split hair is used in drybrush fashion, it tends to look the way grass grows. I brush the same colors over the rocks, but knife out the highlights there with uneven pressure. I also glaze in negative shapes, knife on branches, and drybrush on more foliage.

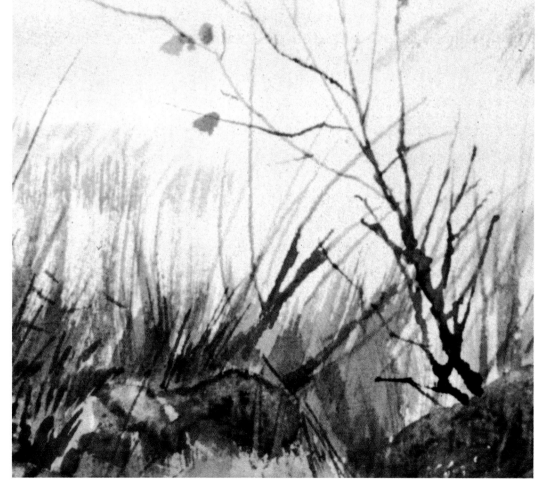

The following demonstration is a study of several textures—wood, grass, and paint—in bright sunlight. My palette is burnt sienna, raw sienna, sepia, cobalt blue, and Winsor blue.

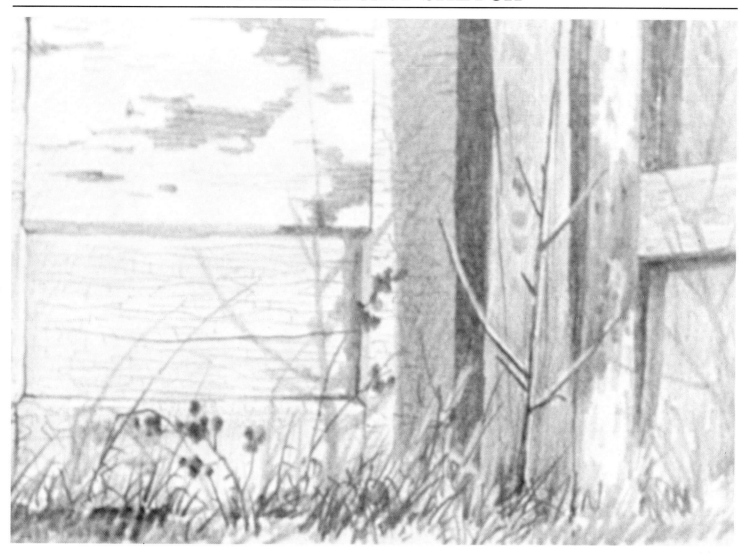

On the dry paper, I start work on the first wooden board. First I mask out the borders on both sides of the board with masking tape. Then, with a mixture of sepia and Winsor blue, I use a combination of stain and drybrush to underpaint the texture of the woodgrain and cracked paint. Where the aged wood is exposed, I only use sepia. I paint the twig that is in front of the boards first, then mask out the bordering edges of the wood behind it when it's dry.

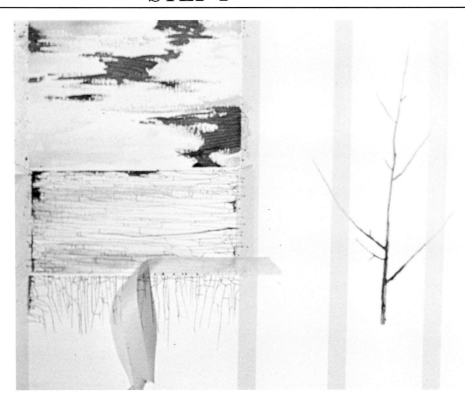

Detail. I paint the texture of the wood directly on the dry white paper with a combination of sepia and Winsor blue or sepia and burnt sienna using drybrush strokes and light washes. The staining strength of these combinations plays an important part in the painting. The sharp, strong lines in the brown tone or on the white paper are scraped in with the pointed tip of the brush handle or cut in with the pointed edge of the palette knife, using rich pigment.

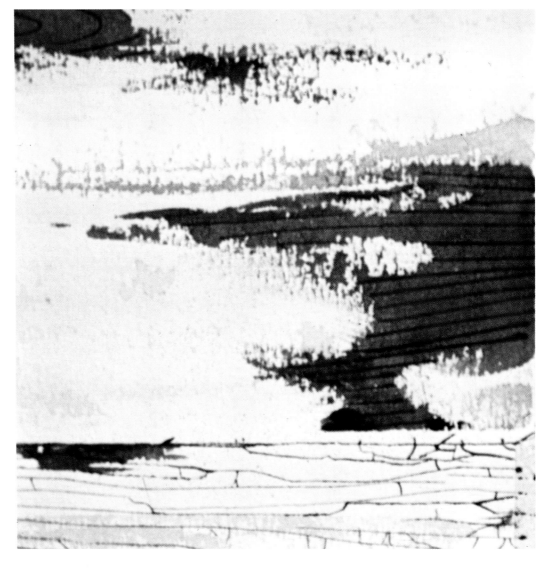

I apply Miskit over the shape of the young tree so I can freely model the woodgrain behind it. There isn't much indication of value at this point; I'm only interested in texture.

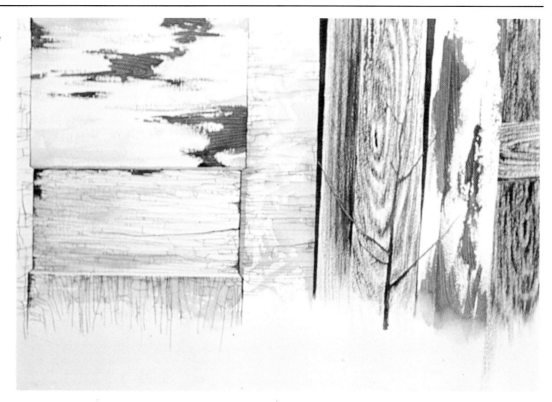

Detail. This is a closeup of the woodgrain. Before I paint each board, I mask out the edges on either side of it. When I'm finished and the paint is dry, I remove the tape and repeat the process so I can paint the next one.

After I peel off the masking tape, I glaze the shadow colors over the established textures with a wash of cobalt blue, burnt sienna, and a bit of raw sienna. I paint around a few large sunlit spots so I don't have to lift them out later. I make no attempt to paint the more delicate shadows yet; I just wash in the shadow as a broad mass. While the wash is still wet, I paint the dry grass below it with a bristle brush and texture it with my palette knife. My colors here are raw sienna, burnt sienna, sepia, and a little Winsor blue.

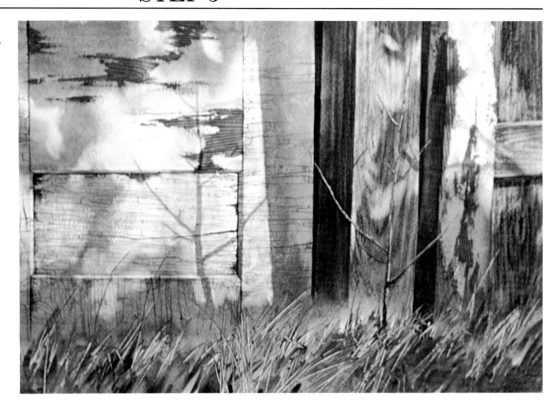

Detail. The luminous blue-gray shadow color glows with reflected light and displays the underlying texture clearly. The warm colors of the textured weeds offer a pleasant contrast to the cool shaded surface of the wood.

After these colors are dry, I lift out the sunlight around the delicate shadows by first wetting the area, scrubbing it with a bristle brush, then blotting off the loosened paint. The young tree is still protected by a layer of Miskit. The shapes of the patches of sun are very important to the design, and when the shadow wash is lifted, the staining texture of the woodgrain and cracked paint shows through. Fortunately, I am able to remove most of the cobalt blue in the shadow wash. The nearly white paper gives me just a little bit of the dilapidated but sunlit texture on the surface I want.

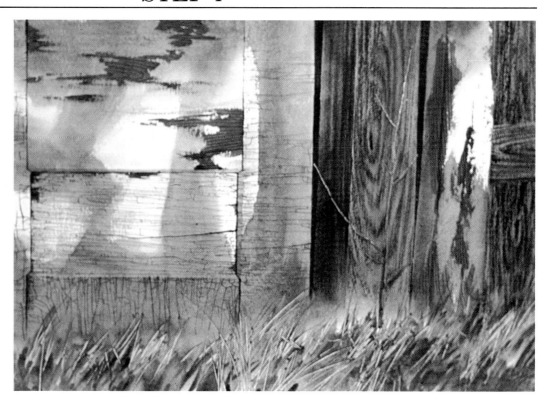

Detail. I paint the foreground weeds and grass with various brushstrokes of raw sienna, sepia, and Winsor blue. Then, while it's still damp and tacky, I knife out individual blades of grass with my nail clipper.

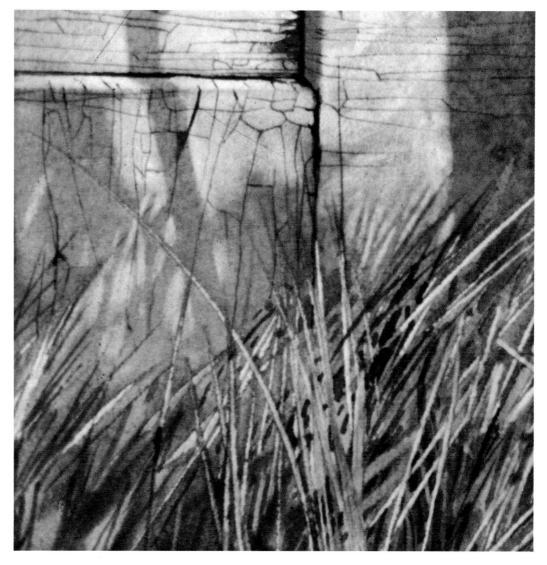

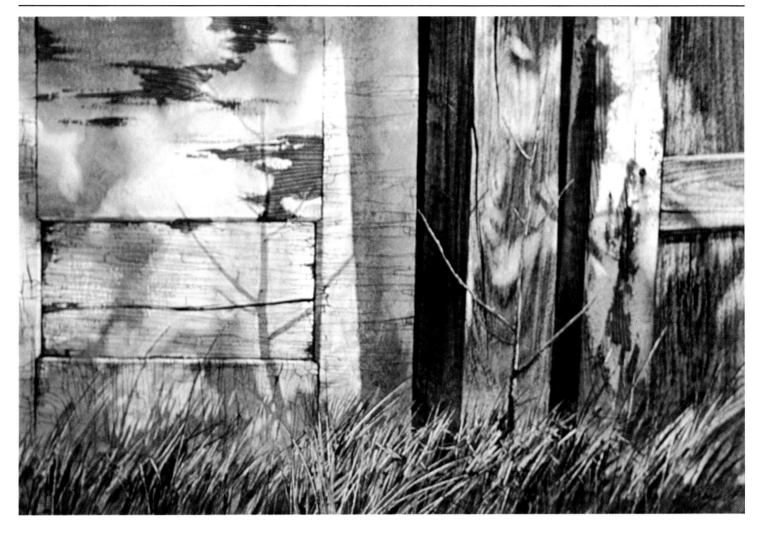

Sun Pattern. Now I finish the details. I paint around the delicate shadows, then remove the Miskit and paint the sunlit tree with burnt sienna and raw sienna. I refine the grass, glaze the dark spaces between the blades of grass, and lift out a few highlights. I also lift out the shadow wash for the tallest blades of grass that lie in sunlight, in front of the shadowed wood. I also refine the wood and paint a few nails in it. The warm and cool colors in the painting now balance each other. The texture is now subordinate to the design and the shapes are much more evident.

Detail. This detail illustrates the chipped and cracked paint and the worn joints between the boards, both in sunlight and shade. As you can see, they survived the scrubbing very well. Also, because the texture was applied equally to both sunlit and shaded areas, the continuity of texture is assured under both conditions.

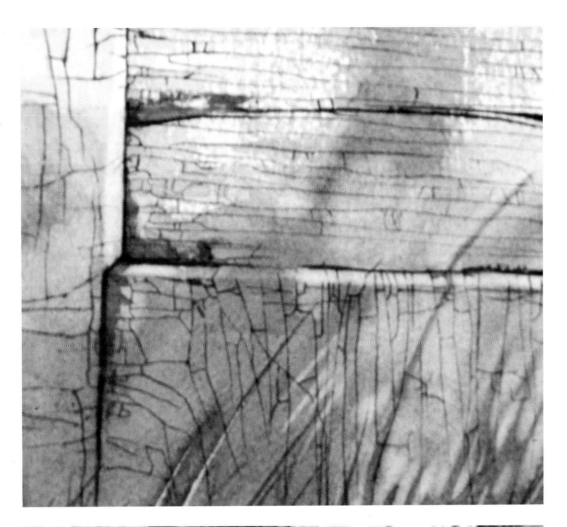

Detail. As I finish the last refining touches, I pick out the cracks in the wood and darken them with more sepia. I also put in a few nails and add the typical rusty streaks beneath them.

Atmospheric Perspective

WET-IN-WET, GLAZING AND KNIFING OUT

This is a study in soft colors of gently moving water. There are also several elements above the water. These land elements and their reflections vary according to their position in the foreground, middleground, and background. My palette is raw sienna, burnt sienna, brown madder, Antwerp blue, and French ultramarine blue.

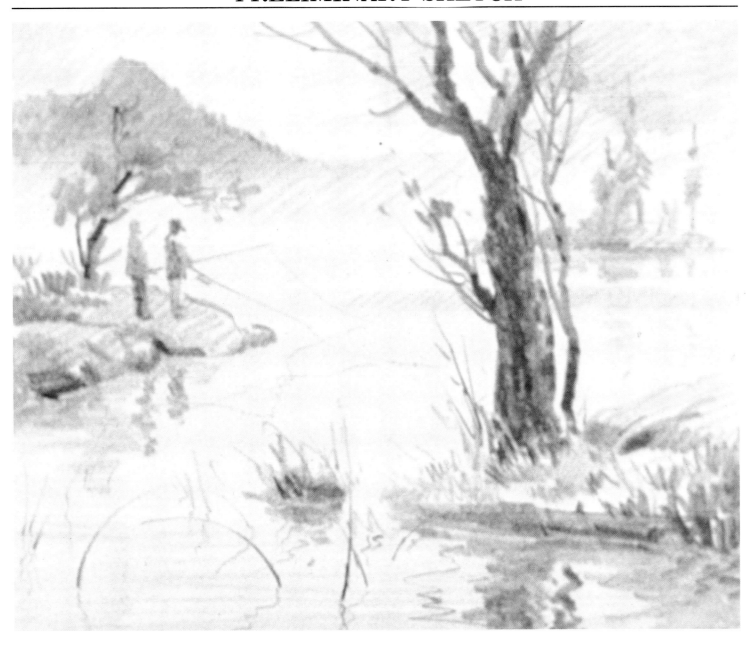

I wet the paper and establish the sky and distant mountains with a wash of raw sienna, the two blues, and a touch of brown madder, in varying combinations. In the wet foreground, where the waves are gently rolling, I use a light combination wash of Antwerp blue, French ultramarine blue, and brown madder. The result even at this point shows the moody play of cool and warm color that hints of a rain shower coming from the right-hand side. The light comes from the left rear center. The raw sienna in this area indicates a thin cloud formation with some strong sunlight behind it.

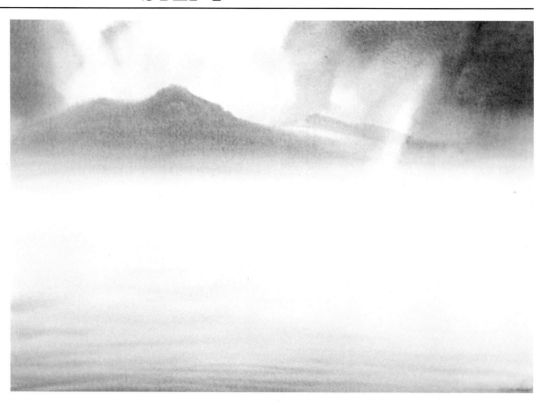

Detail. I carefully time painting the mountains into the wet sky wash, waiting until the first wash loses its shine. Because of this, edges of the distant mountains are soft and furry, which makes it look like they're covered with trees.

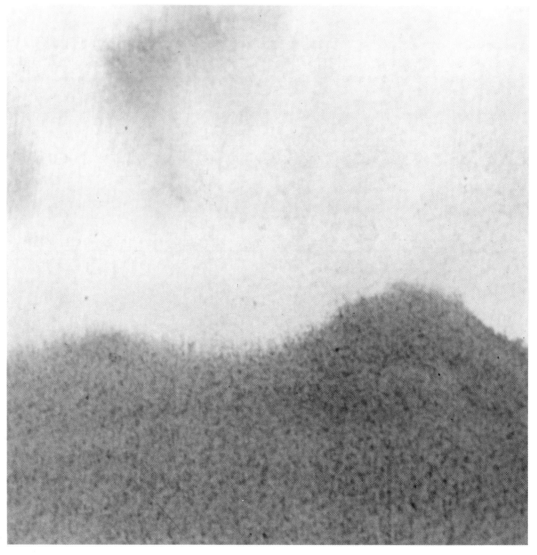

When the paper is dry, I paint the bluish gray silhouette of the evergreens and rocks on the distant tree-covered island with burnt sienna and Antwerp blue.

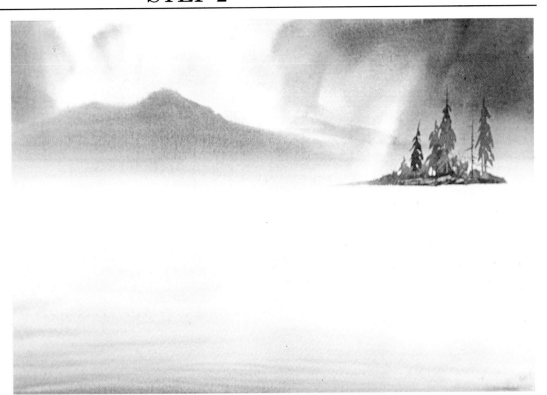

Detail. The single value of the island's silhouette dominates, except for a few modeled details, such as the knife-textured rocks.

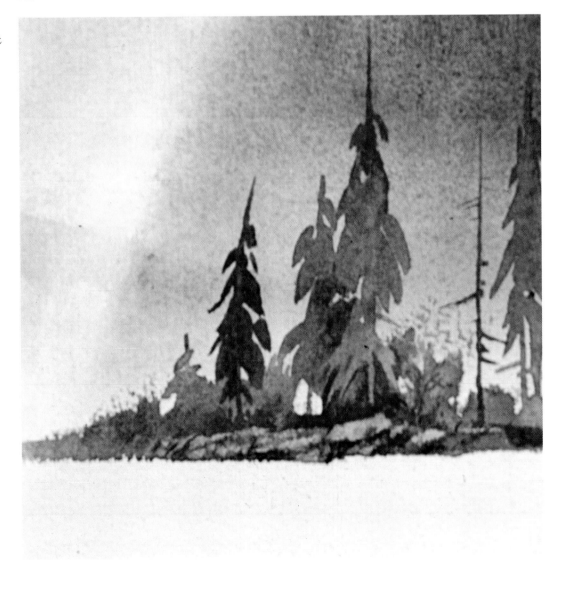

Now I paint the land mass on the left-hand side. Since it's closer, the elements there are better defined (with sharper edges), warmer in color and darker in value than anything painted thus far. I leave room for its reflection in the water, which I plan to paint later.

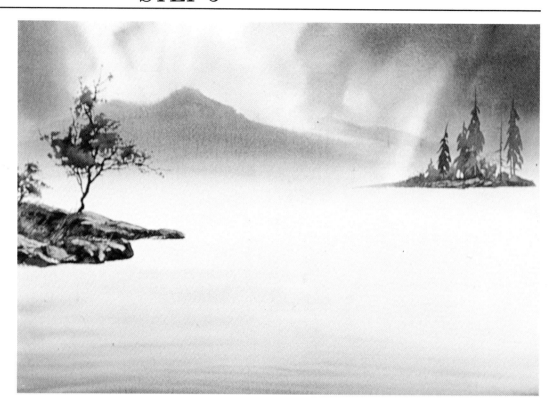

Detail. I painted the rocks with a single-value, heavy wash of raw sienna, burnt sienna, and French ultramarine blue, and modeled the highlights on them with my palette knife.

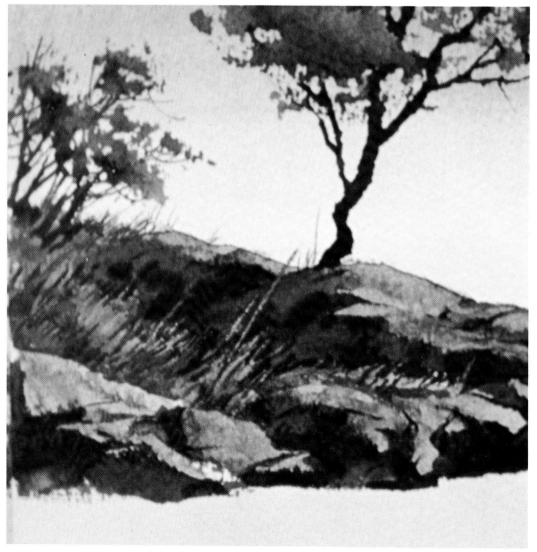

I now paint the closest land mass, with its big tree and fluffy grass. I texture the trunk and branches with a palette knife using raw sienna, brown madder, and French ultramarine blue. I drybrush in the grass with raw sienna, burnt sienna, and Antwerp blue and, while it's still damp, knife out individual blades.

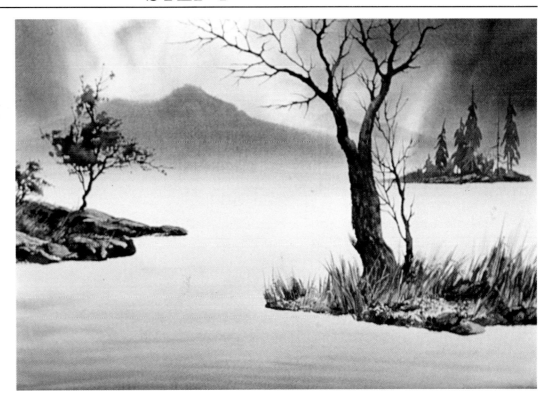

Detail. By texturing the foreground, I enhance the three-dimensionality of the painting. It helps make the foreground *look* close.

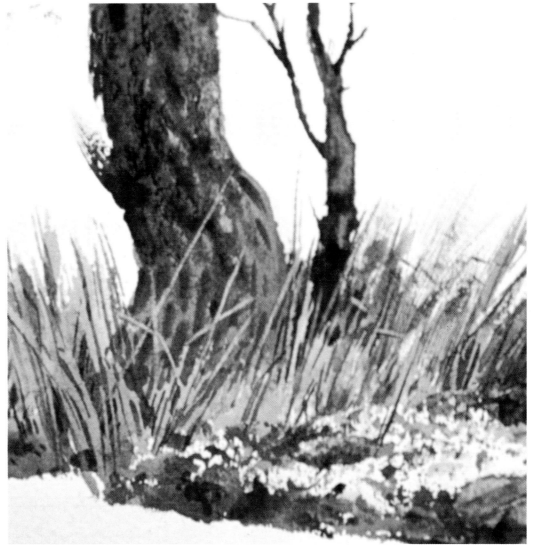

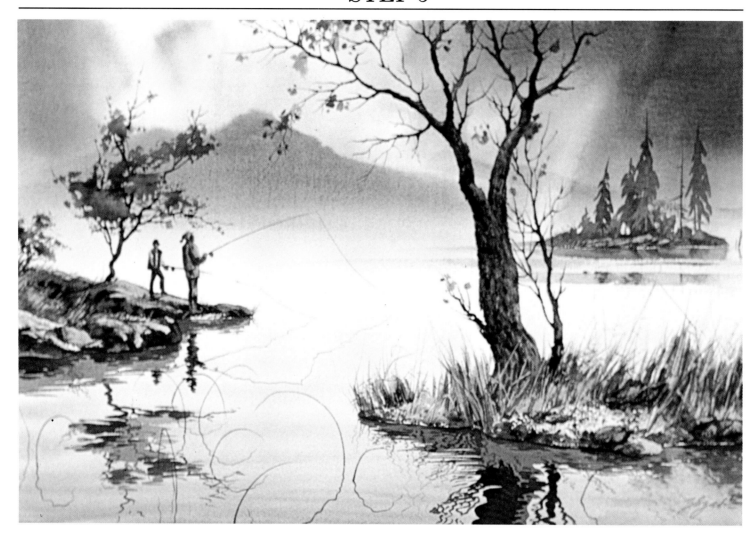

The Waiting Game. I wash in the lightest reflections of the distant island and the two land points first. The wash, a mixture of burnt sienna and Antwerp blue, represents the local color of the water. When it dries, I glaze the darker details on top of the lighter wash with the same color. I also add the thin, curling weeds and paint the two fishermen and their reflections.

Detail. The center of interest in this painting is the two fishermen. They are silhouetted against the light background water, but I paint enough detail on them to make them important and interesting in that position.

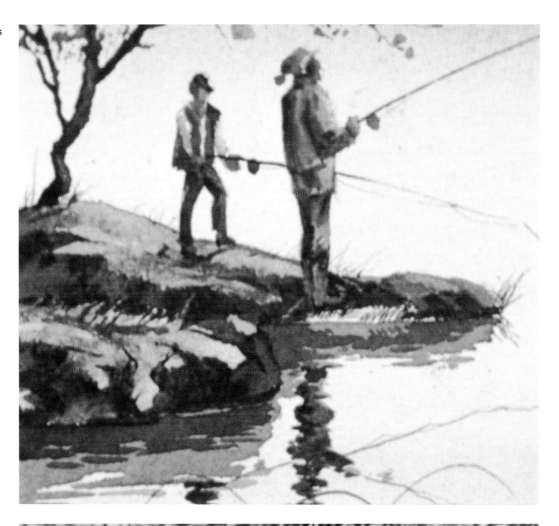

Detail. This detail shows how the light and dark reflections move gently on top of the rolling water. The reflected images are wiggled, not straight.

Dramatic Sky
CONTRASTING COLOR
AND VALUES

This is a study of a very stormy, moody sky, painted mostly on wet paper. I use five colors: raw sienna, burnt sienna, brown madder, Winsor blue, and French ultramarine blue. Winsor blue is the key to the dark values in this painting because it's capable of going extremely dark, yet still remaining luminous, even in the sky, where it's mixed with brown madder.

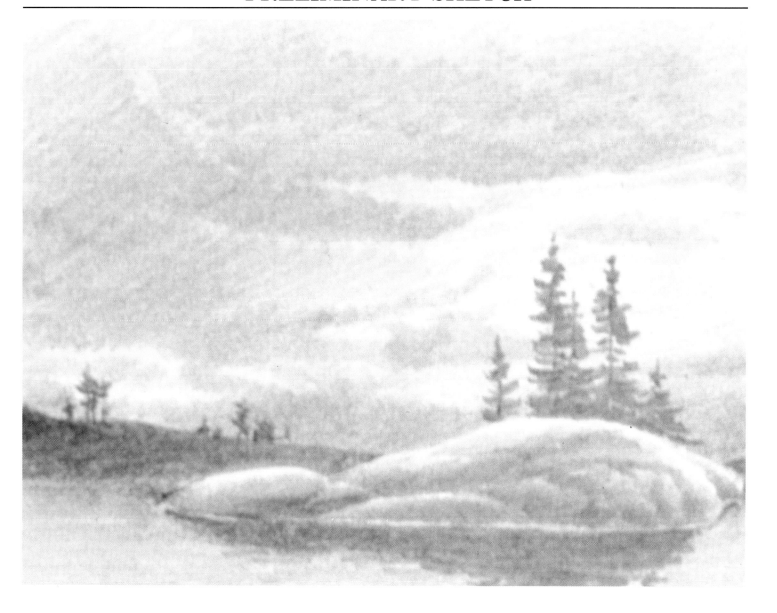

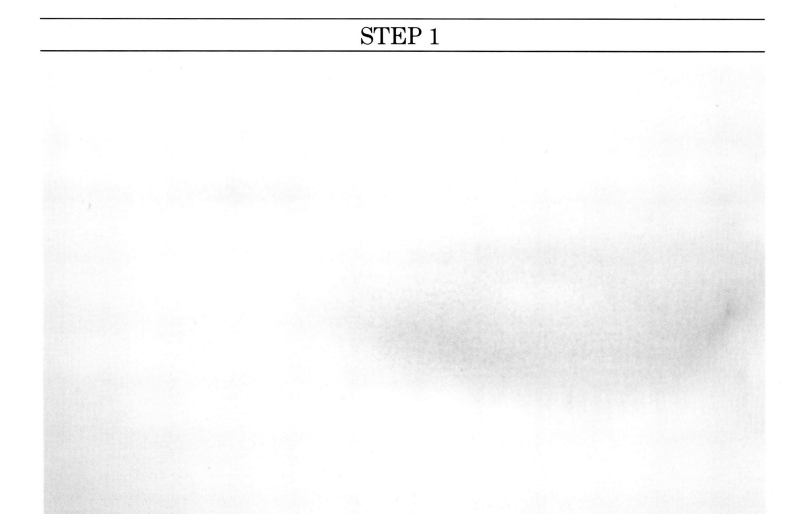

I start on wet paper with a thin wash of raw sienna and a touch of burnt sienna to give a luminous glow to the warm skybreak. This wash represents the stratosphere, the highest part of the sky.

The low-lying storm clouds are dark and forboding. I paint them first with French ultramarine blue and burnt sienna, then I blend brown madder and Winsor blue into the wet washes to give the dramatic darks additional strength and variety.

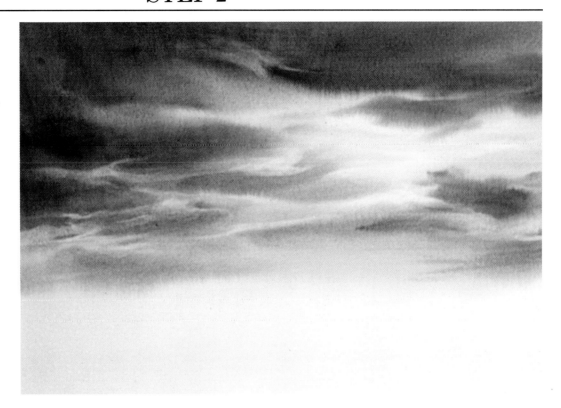

Detail. The blended colors are subtle, but varied. Their value is stronger than their hue. Note the play of warm and cool grays. As the paint was drying and about to lose its shine, I lift out some of the highlights in the windswept clouds by rolling a soft, thirsty brush into the wet paint.

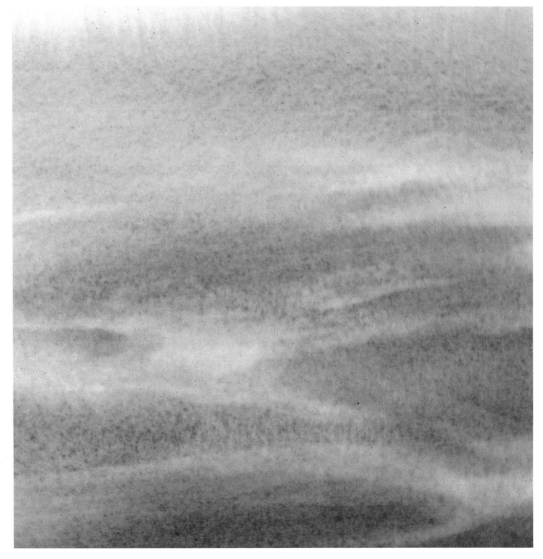

When the paper is dry, I mask out the shape of the rocks on the island to protect their edges while I paint the water and the strongly silhouetted land masses. I use Winsor blue and burnt sienna for the water.

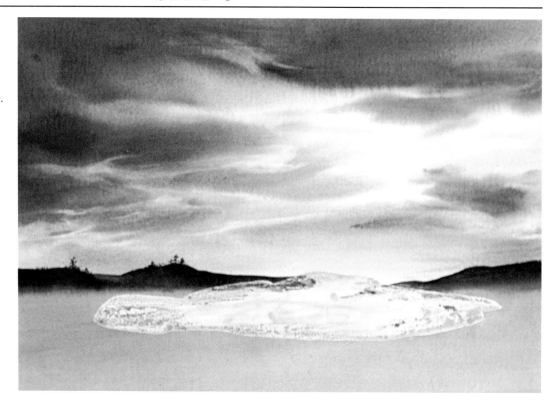

Detail. The contrast between the dark pattern of the solid-colored hilly area and the light, active, subtly detailed sky is strong. Note how the Miskit, which repels water, protects the paper from the staining washes that surround the masked-out shape.

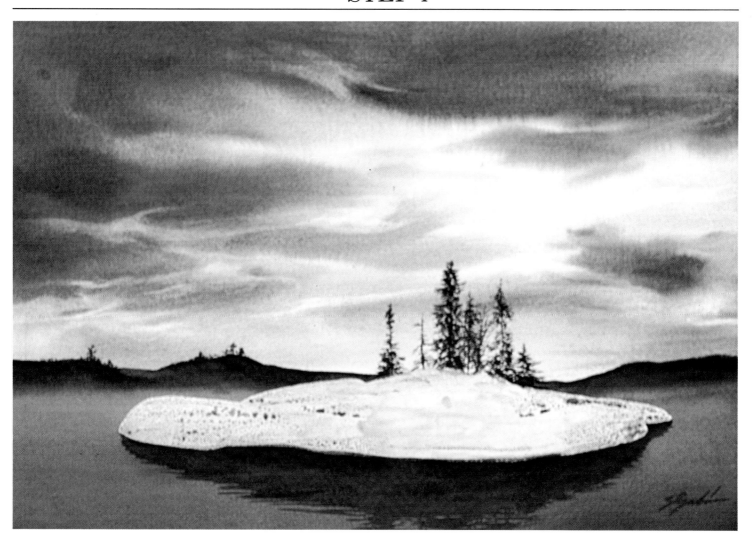

I darken the water further with another glaze of Winsor blue and burnt sienna. After it dries, while the Miskit is still on the paper, I add the dark reflection of the main island and trees.

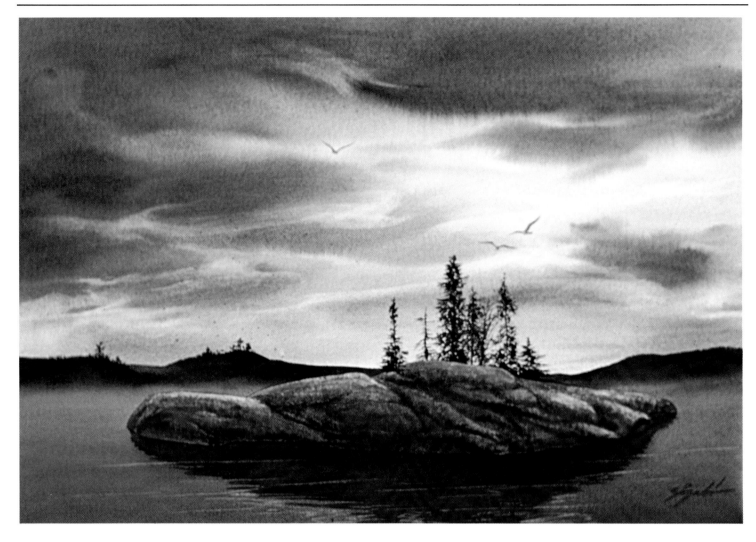

Summit Meeting. I remove the Miskit and paint the rocks with a rich, thick consistency of raw sienna, brown madder, and Winsor blue, and model the highlights on them with my palette knife. Finally, I add a few soaring birds as simply painted accents against the light sky in order to further dramatize the powerful sky.

Detail. The knife-modeled rocks look natural, solid, and contrasty next to the sky and lacy evergreens.

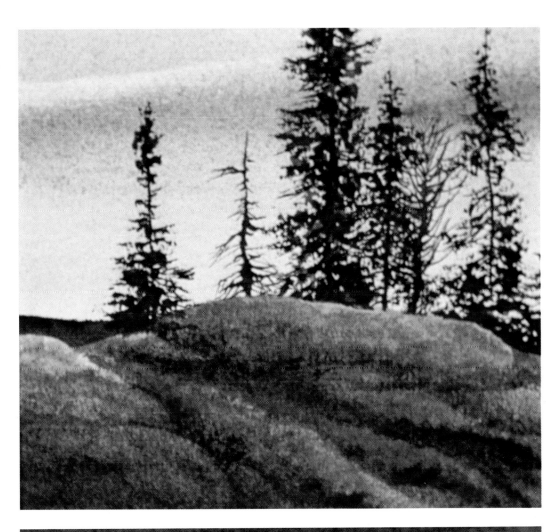

Detail. The textured rocks are warm in color, while their reflections and the water are cool. Accuracy in value is crucial.

Sand Dunes
GRANULATING WASHES AND CALLIGRAPHY

This last demonstration stresses the finishing stages of a painting and the thinking that goes into it. I plan to paint windswept sand dunes and, knowing the nature of my paints as I do, I decide to take advantage of the granulating nature of some of my pigments. As a matter of fact, the sedimentary qualities of raw sienna, when combined with sepia and French ultramarine blue (I also used a little Antwerp blue), are the key to this painting's success.

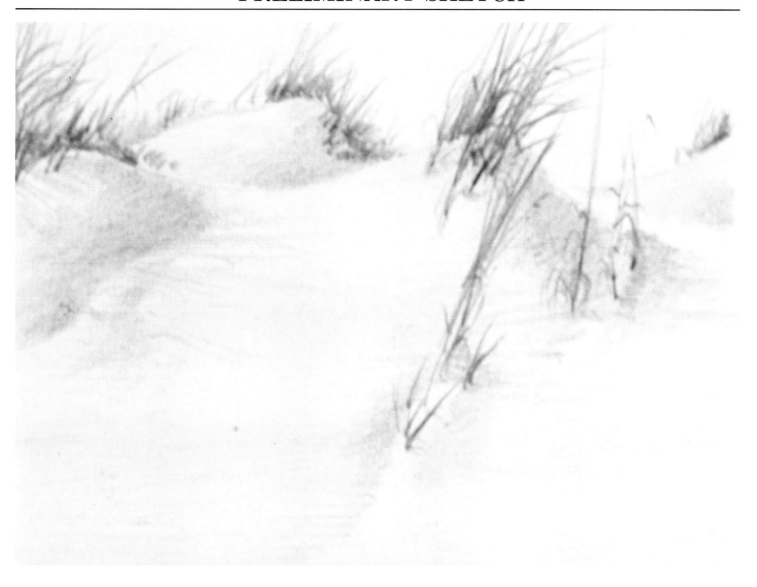

I wet the paper and paint the sky with light washes of raw sienna and Antwerp blue. While the paper is still wet, I establish the sand, using brown washes of raw sienna and sepia with burnt sienna, mixed with French ultramarine blue, its cool complement. The blue neutralizes the brownish color and exaggerates the granular effect, giving the washes the appearance of fine grains of sand. It's particularly successful near the center of interest, the dune at the center right. I record the main values and take the direction of the light (which comes from the upper left) into consideration. Where the light strikes the sand directly, I leave the paper white. I also note the effects of the wind, which ripples the sand in short horizontal stripes.

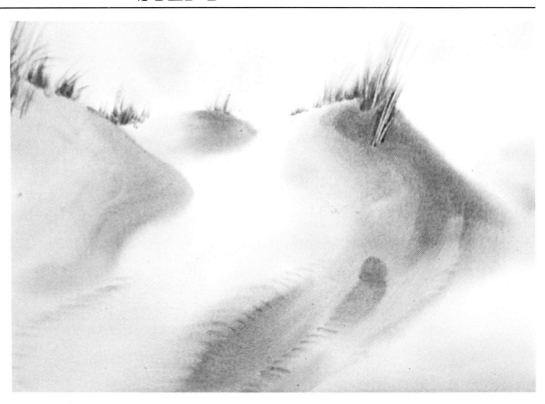

Detail. When the paper is dry, I paint the grass with washes of raw sienna, burnt sienna, and French ultramarine blue, knifing out some of the closest blades with my palette knife. The light-colored sky behind the dunes hints at a sky condition dominated by warm colors that relate well to the sand.

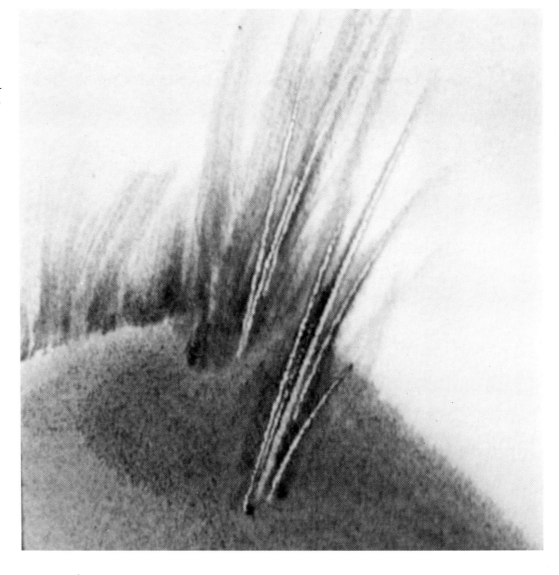

I wipe out the highlights on the ripples of sand and paint some soft, lost edges on the dark side of the ripples. I also contrast the curving path of the dunes with some long dark blades of grass. These vertical weeds help the predominantly horizontal composition, too.

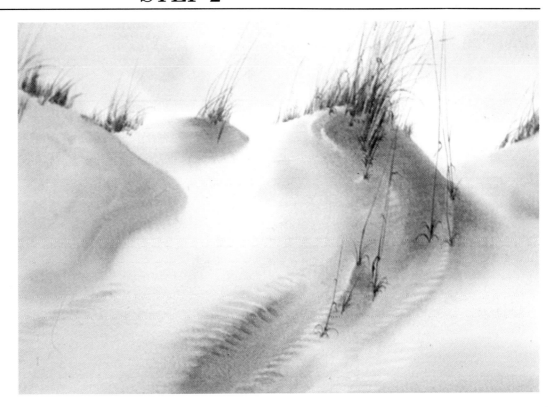

Detail. I further refine the weeds to offer more contrast. I add some darker blades, and indicate smaller shoots at their base, and I bend a few blades to the right to indicate the force and direction of the wind. There is now a greater range of values and texture in this area.

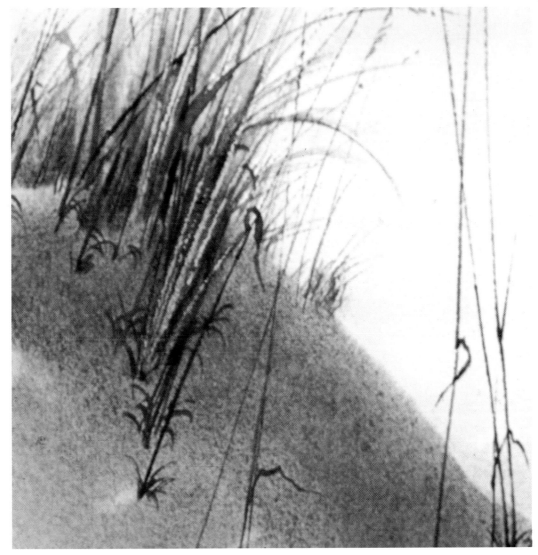

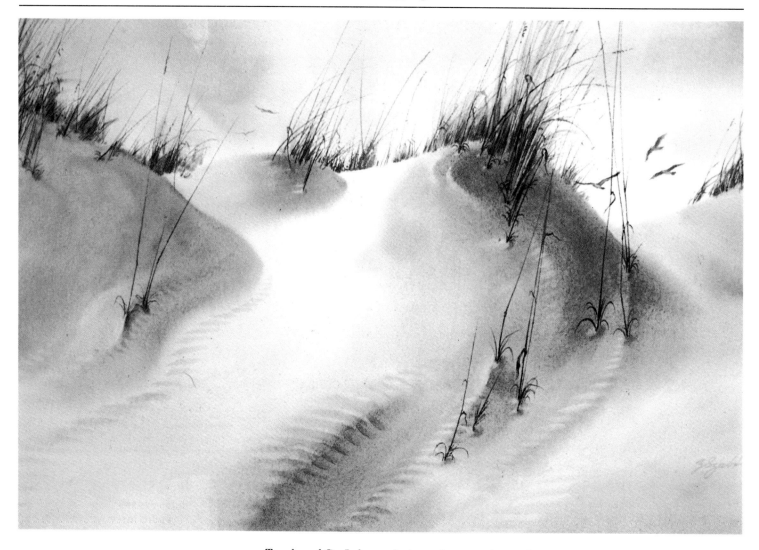

Touch and Go. I glaze a darker value over the sand on the upper left-hand side of the painting in order to reduce the volume of light in that area. I also place additional ripples in the sand, representing the wind's directional rhythm. I add more weeds to the tops of the dunes. To attract attention to the center of interest, I place three fairly good-sized seagulls there. They read as dark shapes against a light background. I also add two smaller, lighter gulls in the distance at the left to create a seaside mood.

Detail. The delicate weeds are painted in with calligraphic strokes. They contrast with the smooth sand and tie the sky and middleground together. I lift out subtle light areas at their base where the light hits tiny mounds of sand that have collected there. The contrast between light and dark areas and between soft washes and hard-edged calligraphy, plus the action of the gulls all draws attention to the center of interest.

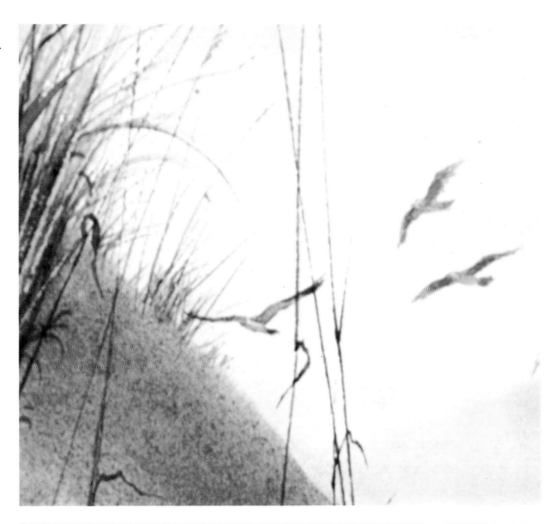

Detail. The same elements as in the detail above are here, but are less emphasized. This area thus complements rather than competes with the center of interest.

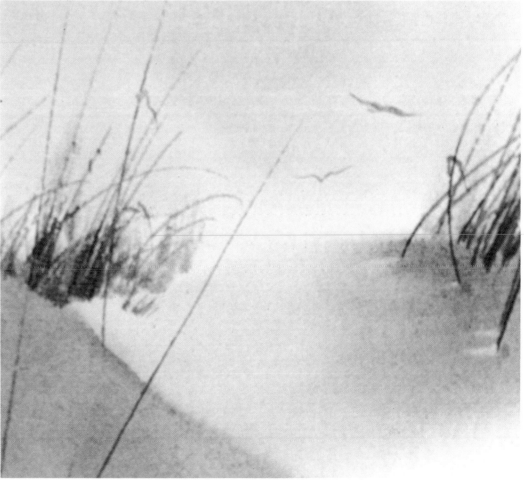

One-Man Show

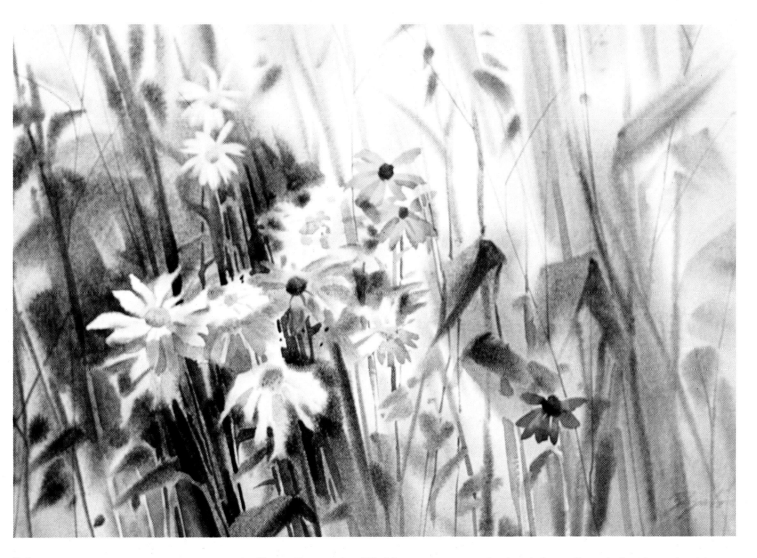

Palette
Burnt Sienna
Raw Sienna
Brown Madder
Sepia
French Ultramarine Blue
Antwerp Blue

Happy Integration. Working on wet paper, I painted the medium-dark soft weeds with a 1-inch (2.5 cm) bristle brush. I worked around the large flowers, keeping their white edges soft by lifting out corrective edges as the paint was drying. As the paper dried, the images I added gradually became sharper. I saved the colored flowers and calligraphic touches for the end. The interplay between positive and negative shapes and warm and cool colors creates excitement and tension in a subtle area. Into the wet softness I glazed on dark shapes, indicating light stems and the depth behind them. The contrast in value and texture favors interest in the white flower. Warm touches of color carefully placed in a large area unite the composition in color. But these touches of color, however subtle they may be, must be planned.

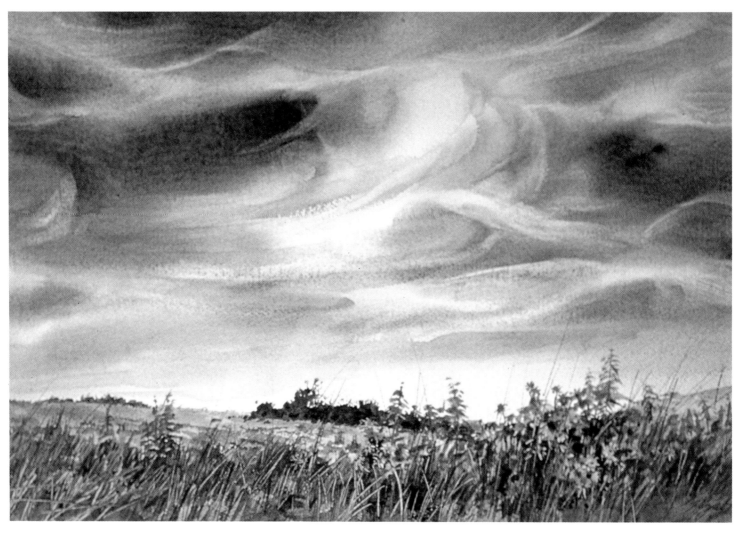

Palette
Raw Sienna
Burnt Sienna
Antwerp Blue
French Ultramarine Blue

Bouquet to the Sky. To create the effect of a big sky, all you need is a small, humble subject to scale it against. A field of autumn weeds worked very well in this case. I painted the sky in wet-in-wet, softly rolling shapes and lifted out the light clouds from the dark background with a rolling motion of a clean, large, soft, thirsty brush. I contrasted these soft edges with other sharp, glazed-on edges of large lost-and-found brushstrokes. Next I painted the shape of the ground surface with a medium-light value of raw sienna, burnt sienna, and a little French ultramarine blue. Into this, I painted the weeds and flowers with raw and burnt sienna. The flowers look yellower because of the dark, cool sky of French ultramarine blue and raw sienna next to them. But, in fact, raw sienna was my brightest yellow.

For the distant, dark clumps of shrubs and the foreground mass of dark weeds, I applied raw sienna and French ultramarine blue, and knifed out the light stems with my palette knife. Their edges are lacy, but not opaque. It's the value contrast between overlapping shapes that creates the feeling of depth. Finally, I accented the flowers with tall, thin blades of grass to encourage a vertical balance.

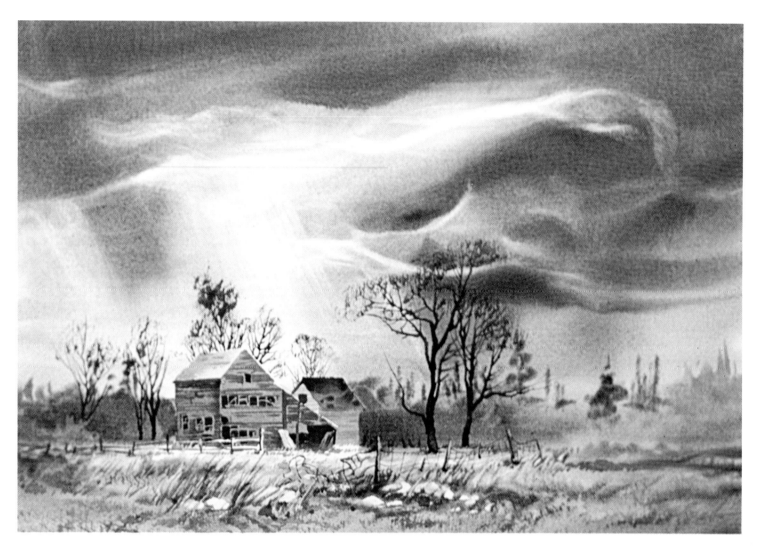

Heaven's Smile. An angry sky seems even more threatening when a lonely, defenseless corner of God's country is placed beneath it. The abandoned buildings, dying old trees, and broken-down fence speak of better days, and the boiling gray clouds tell their own story. On wet paper I painted the sky with French ultramarine blue and burnt sienna. To indicate the whirling nature of these fast-moving clouds, I rolled a thirsty, soft, wide brush into the dark wash of the sky just as it lost its shine. At the same time, I lifted out some rays of light. The straight, light lines of the rays offered relief and contrast to the swirling, dark clouds above. Next I added the shrubs and foreground with raw sienna, French ultramarine blue, and Antwerp blue. I then painted the soft weeds into this wash with a rich brushload of raw sienna and sepia and a little Antwerp blue, and knifed out the light, cream-colored shapes of the rocks from this wash with my palette knife. I glazed on the color and texture of the buildings and, after the paint dried, I knifed in the trees, and drybrushed on their outer twigs.

Contrast in value, color, texture, and softness guarantees the illusion of depth. In this painting, there's a light warm foreground, a dark middleground, and a lighter, cooler background. The shapes of the buildings stand out in sharp contrast to each other and the background. Their isolated, static, stable edges also contrast with the dynamic activity in the rest of the painting. A glazed-on touch of warm brown color breaks into the soft blades of grass with its sharp repeating edges and is sufficient to advance this foreground area toward the viewer in terms of color perspective.

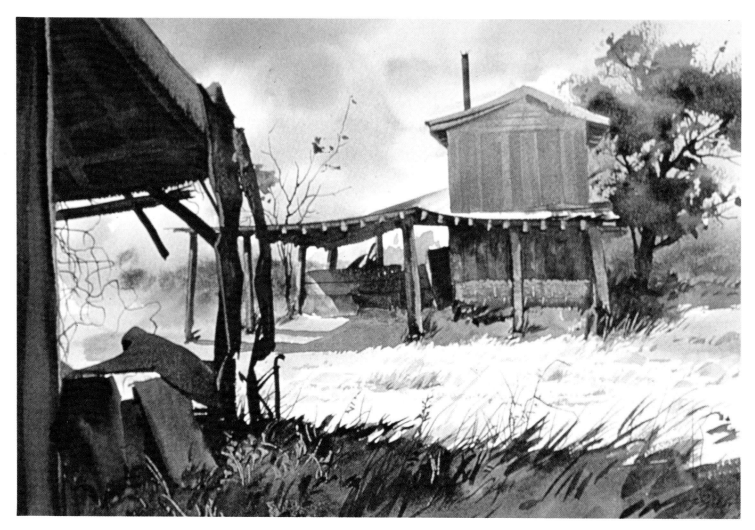

Palette
Raw Sienna
Brown Madder
Sepia
French Ultramarine Blue
Antwerp Blue

Hot Morning. These North Carolina tobacco barns reminded me of happy, tipsy vagabonds. I painted one while sheltered from the blinding sun by the shade of the other one. I painted the humid sky on wet paper, leaving room to add the old structure and tree later. I left the sunlit middleground pure white paper, adding only a few hints of grass to the area. The dark shadow and silhouette of the broken-down structure in the foreground was gently modeled with varying amounts of Antwerp blue and brown madder. I glazed on the shaded part of the building with burnt sienna, brown madder, and Antwerp blue, then knifed out the lighter pillars, cement blocks, and beam ends. I left the brightly lit roof white, as I had the ground area. I applied a second glaze to the upper part of the building, then darkened the wash with sepia and painted the shaded area under the shed. Then I knifed out a few weeds for texture. Sunlit and shaded forms within the same plane are separated by contrasts in color and value.

I painted the tree foliage with a wet soft brush, held loosely so the outer edges of the foliage stayed lacy. Then I painted the branches, weaving them through the foliage shapes to unite them into one tree. I judged all values carefully, using enough water, even in the darkest areas, to keep them from becoming opaque. Where shapes overlapped in different planes, I avoided tension spots by making sure that edges didn't line up with other edges and corners didn't point to or touch other corners. I also changed the values enough to give the painting a three-dimensional feeling.

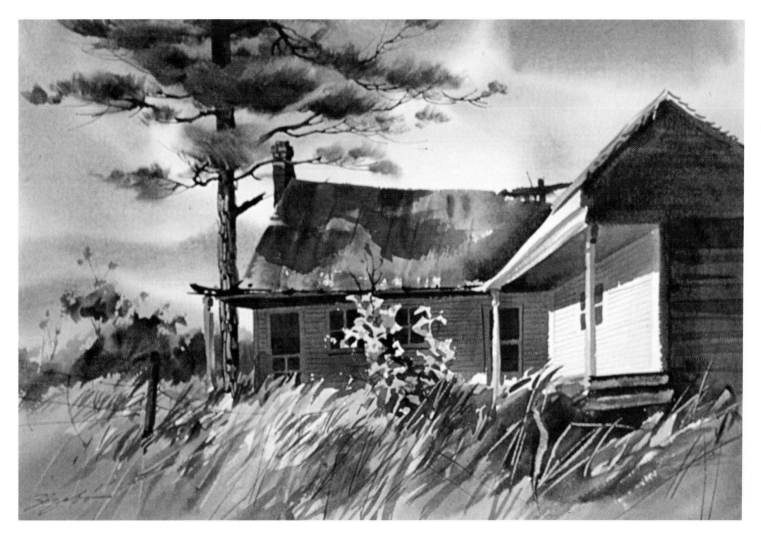

Palette
Raw Sienna
Burnt Sienna
Brown Madder
Antwerp Blue
French Ultramarine Blue

Carolina's House. This was the start of a hot summer day in North Carolina. Before air conditioning, shade offered the only relief to the discomfort of the summer heat. The shade now presented me with lovely shapes contrasting in value and definition. Painting outdoors in the bright sunlight, I wet the paper and painted in the sky, distant hills, and clumps of pine needles. I had to work fast in the scorching heat to paint around the edges that defined negative shapes, yet keep the dark shadow color even, without dry edges in the wrong places. In this case, the foliage represents large shapes that carry the weight of the design. I painted it first on wet paper, and when it dried, inserted the supporting trunk and branches softly in and out of the loose washes. I also textured the sunlit side of the rough bark with my knife.

Then I glazed on the house. I painted the shaded walls with a wash of Antwerp blue and brown madder, carefully avoiding the sunlit tips of the weeds, pillars, and leaves on the young tree, which I left white. I also used the knife to paint the darkest shapes on the house. Then I glazed the shadow on the roof. Under fast-drying conditions like this, glazing is an ideal technique. I freely designed the sharp edges of the weeds, but carefully watched their developing shape. The foreground brushstrokes consisted of various combinations of mixed greens, softly blended. I applied them fast enough so that the previous stroke was still wet when the next one touched it. I then squeezed out the light-colored weed shapes from the wet washes with a palette knife.

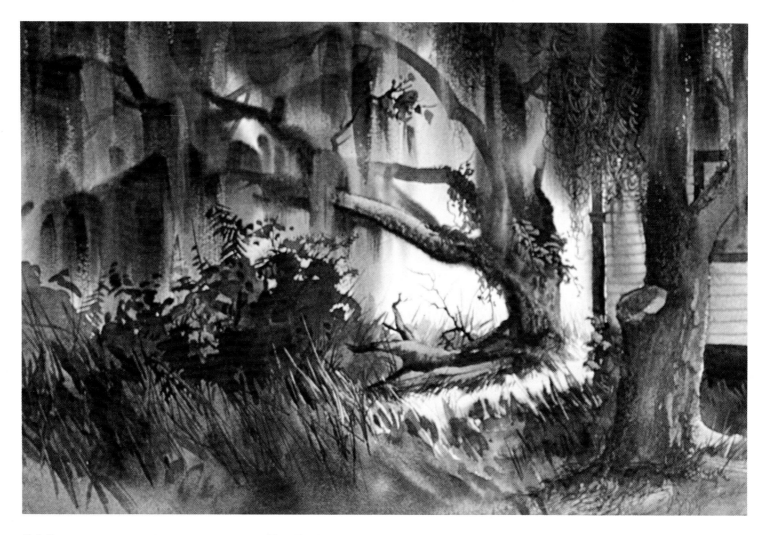

Palette
New Gamboge
Burnt Sienna
Brown Madder
Sepia
Winsor Blue

Hot, Hot Morning. This was my first real confrontation with masses of Spanish moss in the deep South, and I was intrigued by the spooky quality of its soft growth. By using soft and hard edges, and medium and dark values in two different planes in this painting, I give depth to these even, patternlike shapes. I painted the masses of moss and the branches on wet paper with downward brushstrokes of rich color: brown madder, Winsor blue, and sepia. Then I textured the foreground moss with the tip of my nail clipper, and carried the same curly pattern into the lighter background with the dark, thin, curved lines of a thin rigger brush.

The coarse bark of the sunlit oak was painted with raw sienna, burnt sienna, and sepia. Where I textured it with my palette knife, the burnt sienna predominated. The dark value of the distant tree contrasts with the humid yellow background and grass. I painted the few green blades of grass in this area with Winsor blue and new gamboge. Here, light and dark knifestrokes really paid off. Then, with Winsor blue and brown madder, I glazed the shadow on the house and painted in the medium-dark shapes in the foreground grass. I later applied an additional dark glaze of Antwerp blue, brown madder, and sepia to the area and knifed out the thin tall weeds. They lead the eye into the bright sunlight. Then I glazed a light wash of new gamboge over the sunlit area, blending it up into the moss.

Palette
Raw Sienna
Burnt Sienna
Brown Madder
Sepia
French Ultramarine Blue
Antwerp Blue

Raggedy Friends (Right). I painted this on location in northern Ontario. Although the white paper predominates, the painting looks warmer than it really is because of the contrasting influence of the glowing warm trees and cool shadows.

I started by painting the reddish birches on dry paper. My brushstrokes blended softly as they touched because they were wet. Wherever the snow was piled on the trunk, I left a white space. After the paper dried, I drybrushed more texture on the bark with sepia. Then I painted the shadows on the snow with French ultramarine blue, burnt sienna, and Antwerp blue. I knifed in the young trees in the foreground, then painted the flat, elongated tree shadows on the right-hand side quickly so the brushmarks wouldn't show where they overlapped, at the junction of the shadow branches. Finally, I painted the heavy shadows and the distant islet in the snow-covered lake with Antwerp blue, brown madder, and sepia, leaving the sunlit edges of the foreground birches pure white. I painted the delicate needles on the young spruce trees with a split, dry brush and Antwerp blue and burnt sienna.

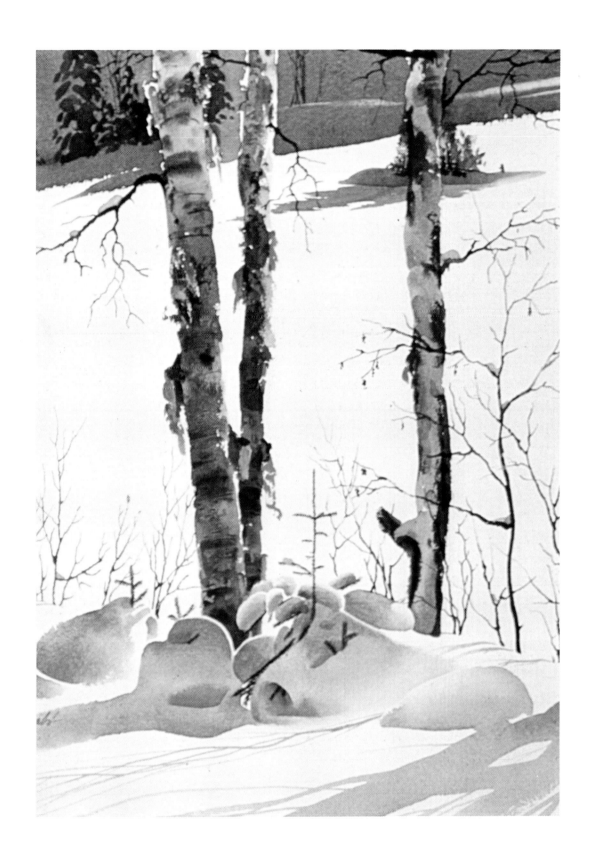

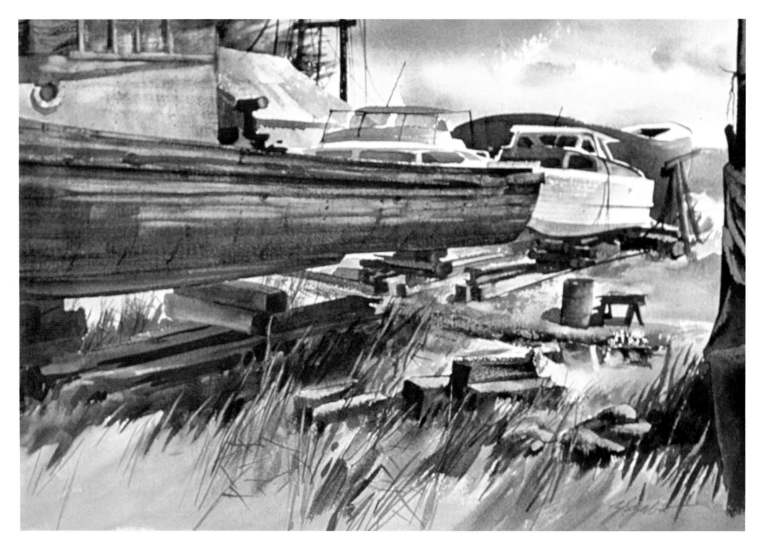

Palette
Raw Sienna
Burnt Sienna
Brown Madder
Sepia
Antwerp Blue
French Ultramarine Blue

Boat Clinic. This old boatyard supplied me with interesting shapes, particularly because the sun was out. Bright sunlight creates great contrasts in value. Also, the difference in surfaces between the new and old boats offered exciting textures to work with. I painted the scene in sections, which allowed one area to dry while I worked in another. I worked the background around the sunlit roof and white boats. I painted the new white boat by glazing on a light shadow color, then textured the large old hull with sepia drybrush on white paper before glazing the shadow color of the aging wood over it. When it dried, I wet-lifted off the textured sunlight portion. The sepia under the shadow color of Antwerp blue and brown madder survived the scrubbing. Where the rust stained the wood, I allowed brown madder to dominate the wash. This concentrated color also survived the scrubbing.

I painted the weeds and clutter on the ground loosely, knifing out some blades of grass and glazing on a few dark accents where necessary. I placed a dark vertical shape at the left-hand side (the foreground boat in shadow) to keep the many receding horizontals from forcing the eye out of the composition. Fast-painted, angled weeds break up the static stability of the square lines of the logs. I brush-lifted and knifed out some light logs and glazed on others as dark background shapes among the light, slender weeds. Subtle details, such as the reflections of the barrel and saw horse in a little puddle, add interest.

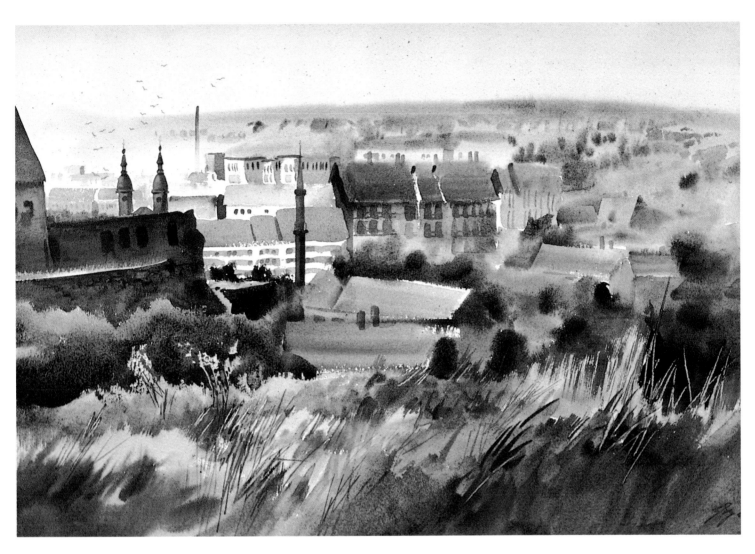

Palette
Raw Sienna
Burnt Sienna
Brown Madder
French Ultramarine Blue
Antwerp Blue

History's Mark. The old Hungarian city of Eger displays centuries of different cultures. The morning mist, weaving around various buildings, exposed the silhouetted shapes of the ancient fort wall, the steeples of a Catholic church, and an ancient Turkish minaret. Where the minaret, which is a strong shape, joins the other buildings, sharp contrast and active, angled shapes dominate. But I painted the rows of buildings on wet paper, which made their edges soft and blurred, in order to reduce their impact in an unimportant, secondary location. A strong contrast in value demands attention and strongly suggests differences in perspective.

For example, the neglected weeds, strongly lit in the middleground, contrast with the dark wall behind them, which helps give an illusion of depth. The warm sunlight on the tiled roofs was carried into the distance without much definition.

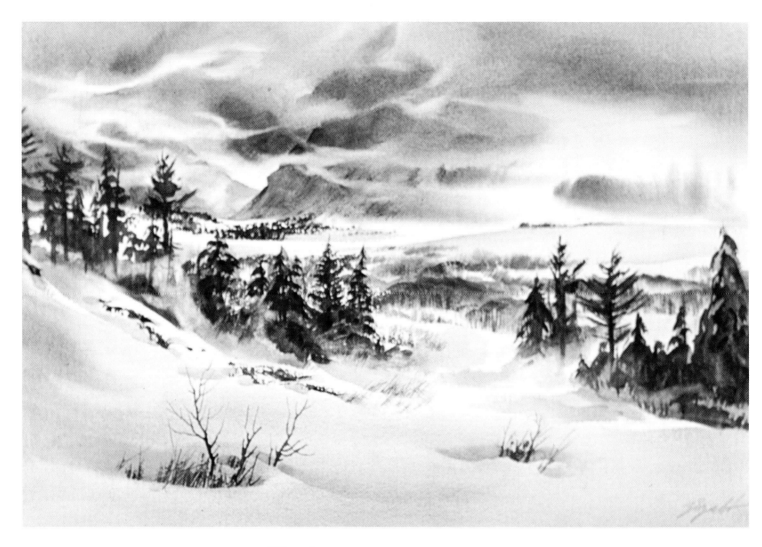

Palette
Burnt Sienna
French Ultramarine Blue
Raw Sienna
Antwerp Blue

Winter Songs. Winter bares its teeth in the threatening mood shown here. Windblown snow and clouds compete for the greatest movement. French ultramarine blue and burnt sienna in varied combinations give a gray mood. The soft shapes are the result of wet-in-wet painting, while lost-and-found edges give form and definition to the mounds of snow above the partially exposed rocks. In the middleground, I lifted out the shapes of the blowing snow from the already dry, dark tones with a wet bristle brush. The foreground weeds and shrubs were made with linear strokes of drybrush and touches of a palette knife in a dark tone. Their warm color and textured shapes make them feel near in perspective. In contrast, the cooler colors and less textured shapes of the distant mountains make them recede. To give the illusion of three dimensions, values and scale must be consistent within each plane of distance.

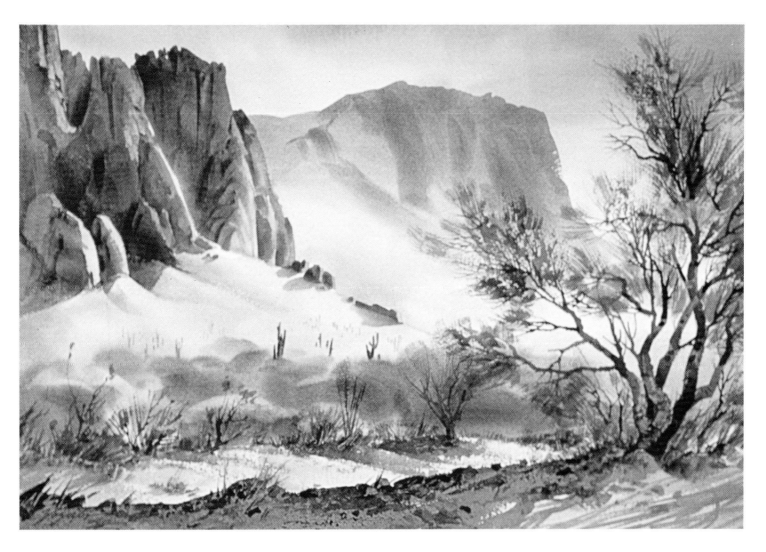

Palette
Raw Sienna
Burnt Sienna
Sepia
Antwerp Blue
Cerulean Blue

Magnificent Superstition. The Superstition Mountains in Arizona have a fascinating quality: they hardly ever repeat the same mood. Here, in the morning light, some mist has softened the rear mountain. The magnificent mountains are awe-inspiring, but their size is deceptive; they appear smaller than they really are. The saguaro cacti creeping up the slopes of the nearest mountain gives a clue to their relative size and scale. I painted the sky on wet paper with cerulean blue, Antwerp blue, and light raw sienna. I followed this with the distant mountains, working on dry paper with fast brushstrokes blending with each other, gradually losing the bottom edge for a feeling of mist. I painted the nearer mountain with separately applied glazes of burnt sienna, sepia, and cerulean blue, then painted the soft shrubs in the middleground on wet paper with cerulean blue and burnt sienna.

The tall saguaros climbing the lower slopes rise above the mass of shrubs. To give the effect of more cacti getting smaller in the distance, I placed a diagonal drybrush accent in the middle of the light slope. Note the brown glow around the soft brushstrokes; it's caused by the burnt sienna and cerulean blue separating on the wet paper. I drybrushed the palo verde trees, rocks, and shrubs in the foreground with raw sienna, Antwerp blue, and sepia, and textured the larger trunks and rocks with my knife. Burnt sienna gave the rocks a warm glow, and the granulating nature of sepia and cerulean blue textured the rocks and made them look coarse and lumpy. The branch structure and green color of the palo verde tree make it a delicate contrast to the massive mountains. I knifed out some textured highlights on the bark and spotted in a few dark contrasting accents on an occasional branch and rock. I glazed on the shadows with Antwerp blue and sepia at the end.

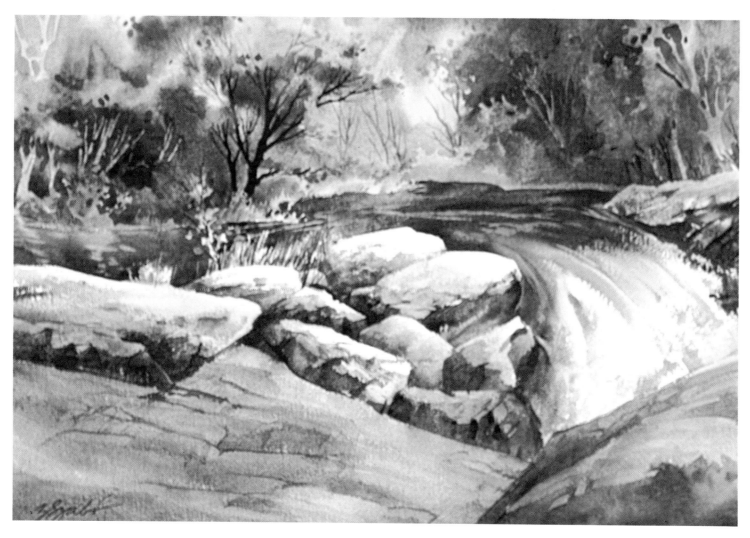

Palette
New Gamboge
Raw Sienna
Brown Madder
Sepia
Cerulean Blue
Sap Green
Antwerp Blue

Down the Hatch. With the coming of autumn, nature has dressed up in bright colors and the creeks have turned into churning waterfalls. Clean, sparkling colors dominate. I kept the bright colors in the distance and the neutrals up close. I painted the scene in sections, one at a time. First I roughly painted the boulders and textured them with my palette knife. When they were dry, I applied a blue-gray glaze of brown madder and Antwerp blue over them. The gushing water was painted with a wash of raw sienna, brown madder, and sap green, using fast brushstrokes applied upward, against the current. The lacy droplets of water were drybrushed on at the same time with the curved belly of my side-held brush.

Warm colors blending on wet paper unite the tree areas. I clarified some details by glazing on lost-and-found shapes. First I painted the foliage of the trees. Later, after the paint dried, I put in the dark tree trunk and interwove the branches into the soft foliage with my palette knife. I lifted out the reflections of the trees in the water. The brownish color came off and the sap green stain showed through in a bright, light value. The distant misty area contrasts in color and value with the foreground, forcing your eyes to travel into the distance.

Palette
New Gamboge
Raw Sienna
Burnt Sienna
Brown Madder
Antwerp Blue
French Ultramarine Blue

Breathing Gorge (Right). Mountain streams are sometimes forced to squeeze through narrow cracks between rocks. There they turn into vaporized falls, forcefully eroding the rocks and dragging debris with them. I painted this on location in Glacier National Park, Montana. I started the top third on wet paper and established the sunlit forest in the mist. I painted the rocky mounds next and textured them while wet with a palette knife. I left the sunlit spot on the center rock bright and well textured. I knifed out a few weeds and painted on the silhouetted (backlit) trees after the paper dried. Finally I glazed on the swirling water, indicating the changes in the direction of flow with quick drybrush strokes that moved upward from the darker waterholes toward the lighter peaks. Then I lifted out a few highlights.

Contrasts in texture and value not only explains the difference between materials but create depth as well. Diminishing values and fewer details give birth to mysterious shapes interlocked into a unit receding deep into space. The tormented tree skeletons appear to advance in contrast to the colorful background that has little definition. Because of the isolated nature of the tree, I added just a few light spots on the trunk with my palette knife. I treated the partially exposed trunk caught in the tumbling water similarly. I also painted the branches with my knife.

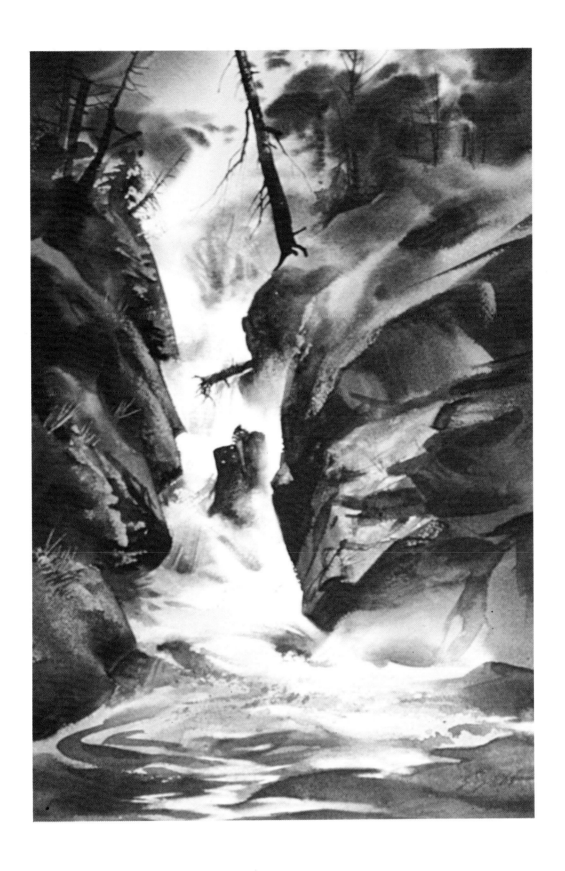

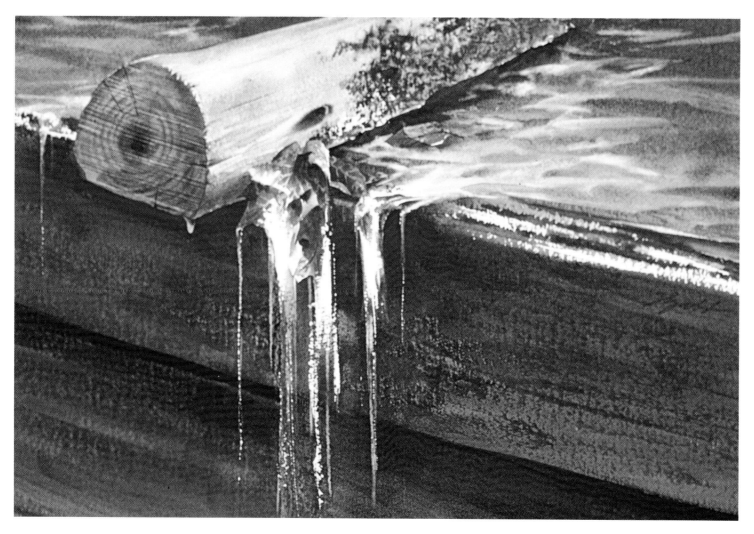

Palette
Raw Sienna
Burnt Sienna
Brown Madder
French Ultramarine Blue
Antwerp Blue

Unintended Bath. My intention in this painting was to capture a moment in time. I painted the center of interest, the clump of leaves jammed against the wood, first. The force of the overflowing water was ready to toss them over and thus destroy my subject, the beautiful shapes of the dripping white water. I quickly snapped a black and white Polaroid photograph before the scene was washed away. I paid more attention to the design and detail of the leaves than to the other, complementary elements. My rapid brushstrokes struck the right note for the painting. The resulting freshness survived to the end. I painted the other areas last: the shaded trough, mossy wood, and shimmering water next to the leaves.

I began the texture of the wood with a smooth wash of brown madder and Antwerp blue. I painted the shaded cut end with the same color, but scratched dark saw marks into the wet wash. When it dried, I wet-lifted highlights from the grooves in the wood and blot-lifted out the single droplet of water next to the dripping leaves. Finally, I tapped drybrush touches of raw sienna, French ultramarine blue, and Antwerp blue onto the damp surface of the wood to represent moss. The water was painted around the leaves with burnt sienna, French ultramarine blue, and raw sienna, with the latter dominant. I wiped out the highlit ripples with a damp brush and glazed on the water's color over the submerged part of the leaf. I wet the paper and lifted out the translucent shapes of the dribbles from the dark drybrushed wood. Finally, I scraped out thin beaded lines of dripping water with the corner of a sharp razor blade.

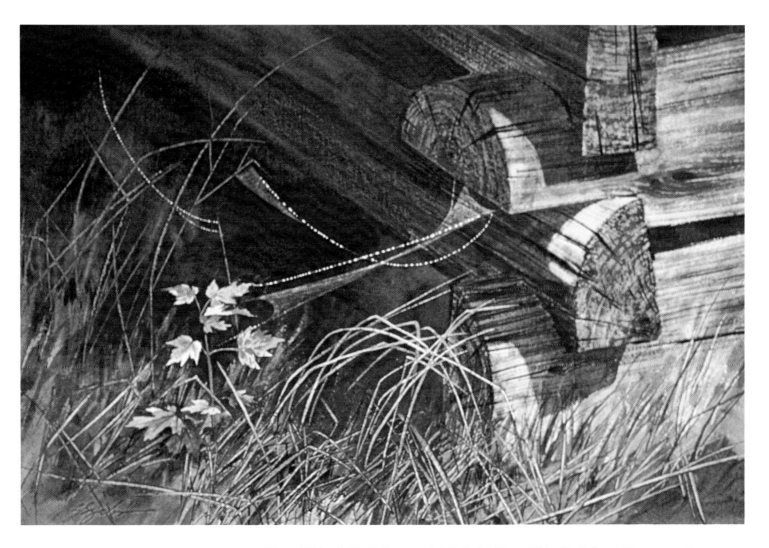

Palette
Sepia
Raw Sienna
Burnt Sienna
Brown Madder
Antwerp Blue
French Ultramarine Blue

Ties of Friendship. I discovered this little 'live still' in Gatlinburg, Tennessee. Here was a little touch of young Canada in the tiny maples leaves tied to an old America log cabin by spider webs, and it struck home instantly. First I drybrushed on the texture of the logs on the dry white paper with a dark value of sepia. Then I masked out the baby maple and some accompanying weeds in the sunlight with a carefully painted coat of Miskit while I finished the dark area behind it with free, vigorous brushstrokes and dark paint. I glazed on the shadow value of the log, with French ultramarine blue, burnt sienna, and raw sienna. When it dried I added the lush weeds in contrasting values of raw sienna, burnt sienna, Antwerp blue, and French ultramarine blue, and worked the handle of my nail clipper into the wet washes to get light, crisp lines. When the paper was dry, I lifted and blotted out the sunlight on the logs. The drybrushed sepia survived my glazing and scrubbing out in the sunny area and shows off the lovely aging texture of the wood. I touched up only a few dark cracks with sepia later. I also lifted and blotted out the soft transparent shape of the cobweb.

Note how I varied my technique according to whether the cobweb was in sunlight or shade. I painted the shaded areas with carefully controlled, soft, wet-in-wet washes and masked out the shapes in the sunlight so I could get sharp, hard edges. I then removed the Miskit and finished painting the young maple with washes of raw sienna, brown madder, and Antwerp blue. Last, I scraped out the highlight on the cobweb with the tip of my razor blade. Note the different textures achieved through recovered luminosity and masking out. Lightening an area by blotting and lifting out color produces softer edges and more subtle coloration, while sharp edges and clear hues are obtained by first masking out an area, and painting the background, then removing the Miskit and glazing on a clear transparent wash.

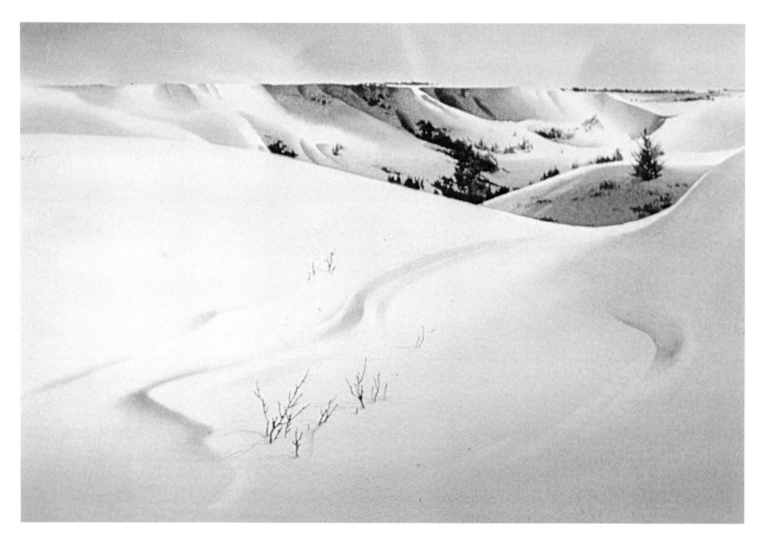

Palette
Burnt Sienna
Raw Sienna
Sepia
French Ultramarine Blue
Antwerp Blue

Hushed Majesty. Rolling hills of snow like these create abstract shapes and reflect the most unusual colors. This Montana scene was like a porcelain masterpiece sculptured by God. The country was massive, and I had to pay careful attention to scale. I wet the sky area and painted it only to the horizon with Antwerp blue, French ultramarine blue, and raw sienna. I gave the huge white hill in the left foreground a soft glow with a raw sienna wash. Then I painted the large snowdrifts on the distant hill. Both the large hill and snowdrift were painted wet-in-wet with lost-and-found edges. I lifted out the highlit edges with a wet brush. There are clearly defined differences in color temperature between the lower sky and the snow in the valley. The soft shadows in the valley reflect the deeper blue sky directly above.

I painted the evergreens and the tips of the foreground shrubs on dry paper using Antwerp blue and raw sienna in the sunlight, and Antwerp blue and sepia in the shaded parts. The scale of the descending trees was correct in perspective. Except for the static horizon, every line here is dynamic. The delicate details in the foreground are designed to lead the eye toward the center of interest in the middleground, and the curving shapes lock into each other as they move into the distance. The changing values on the horizon line prevent it from leading the eye out of the picture.

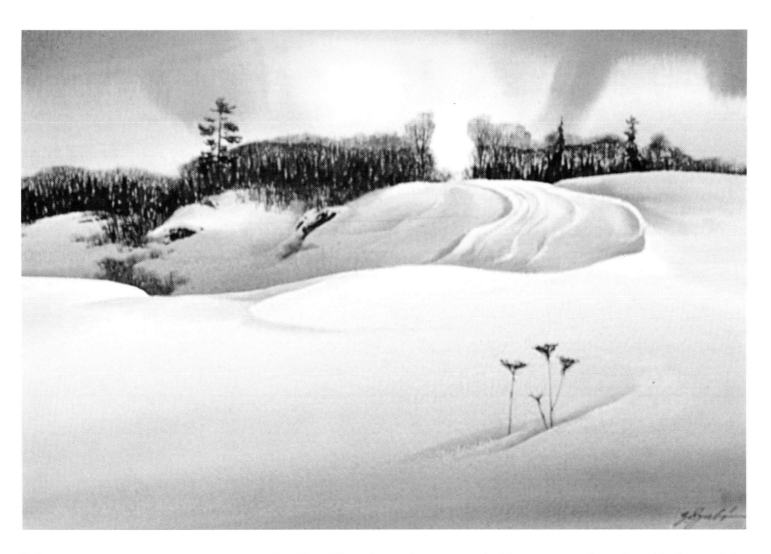

Palette
Alizarin Crimson
Raw Sienna
Burnt Sienna
Sepia
French Ultramarine Blue
Antwerp Blue

East View, Winter Sunset. As you can see in this snowy scene, the eastern side of a sunset sky is often as spectacular as the west. Here the tips of the shadowed trees are lit by the setting sun, while the snow and sky are bathed in a glowing warm light and pale cool shadows. I painted the sky and foreground shadows on wet paper. I started the warm glowing light with a pink (alizarin crimson) underwash onto the wet paper. After I glazed on the blue shadows and lifted out the highlights on the heavy snowdrifts, the pink came through. The sunlit peaks of the trees show the sharp shadow line cast by the edge of the hill behind me.

The sharply defined hollow at the upper right was obtained by painting a large wash on dry paper, then modeling and softening the top edge. The shrubs and distant forest were dry-brushed on in a dark shadow value of sepia. They complement the colorful sky and snow and provide a contrast in texture. The lost-and-found shadows on the little drifts under the weeds are deepened by their contrast with the light areas, which I gently lifted out with a damp brush. I placed the snow-embedded cluster of Queen Anne's lace in the foreground for scale.

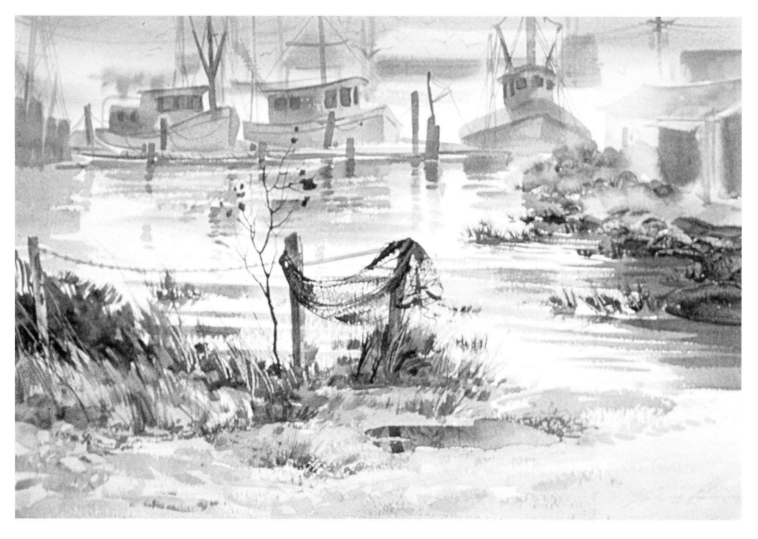

Palette
Raw Sienna
Burnt Sienna
Sepia
French Ultramarine Blue

A Day Off Work. This quiet shrimp harbor was enveloped in mist. I painted this scene on location, working wet-in-wet. That is, I soaked the paper thoroughly and worked from background to foreground items; as the paper slowly dried, my edges gradually changed from soft and blurred to hard hard and sharp. Finally, when the paper was completely dry, I drybrushed on the closest, most crisply detailed elements. The crispest drybrush strokes are on the old net and are surrounded by slightly less defined drybrush strokes. I used a soft wide brush that was well loaded with French ultramarine blue and sepia, starting slowly and speeding up for a drybrushed effect. The slow-painted area is more solid in color, while the more quickly painted area has an open, spotty, netlike texture. I also knifed out a few lights and painted in the strings of the net with a rigger brush.

The soft, light value and smooth surface of the water makes it appear farther away than the darker, more textured foreground in spite of the neutral color of both areas. I made the foreground a little warmer, however. I glazed the boats on top of the softly blurred images in the background in washes of almost the same value. But because their edges were slightly harder, they appear to advance slightly. The warm touches of color in the middleground boat indicate rust. The color was grayed slightly, however, so it stays in perspective and doesn't appear to advance.

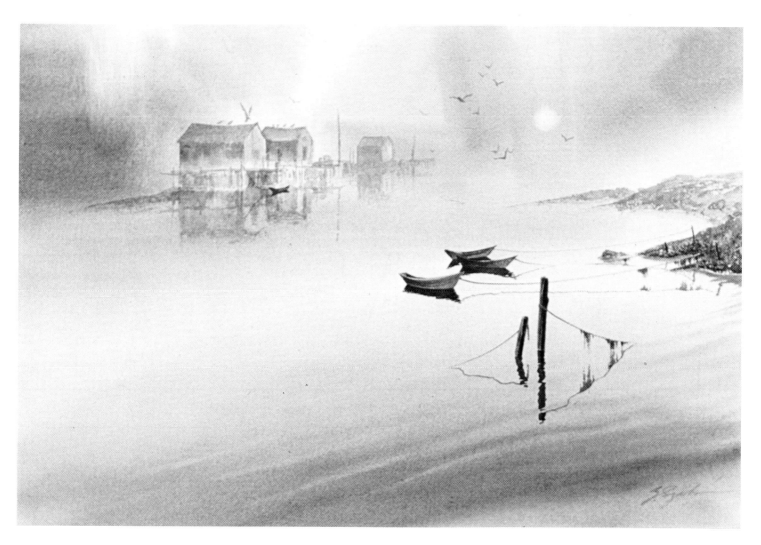

Palette
Raw Sienna
Burnt Sienna
Sepia
French Ultramarine Blue

Distant Watch. Quiet and tranquility set the mood for this painting. I established the soft values on wet paper. The warm color in the sky is raw sienna alone, the grays are burnt sienna and French ultramarine blue. My emphasis is on the distant single dory and the three closer ones, which are related in value. The little group of contrasting images show the surface of the water by their wiggly reflections. The shore rocks decrease in color, value, and texture as they move into the distance. The buildings were painted on dry paper; their details were carefully simplified. The huge gull landing on a roof adds a touch of dynamic movement to the area. The warm color in the distance indicates that this fog is merely a local condition; the sun is slowly burning off the fog. I lifted out the sun behind the mist by gently moving a wet brush around and around until the pigment was loose. Then I quickly blotted it up with a paper tissue.

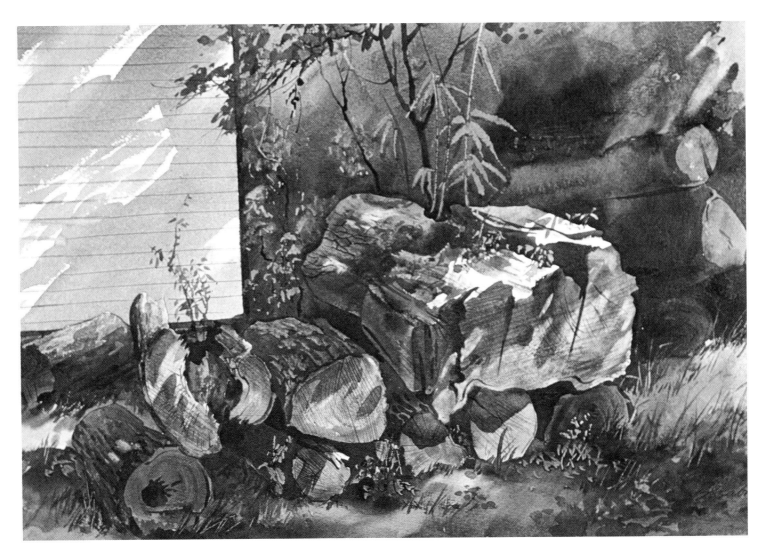

Palette
Burnt Sienna
Raw Sienna
Sepia
Sap Green
French Ultramarine Blue
Antwerp Blue

Surprise in Light. This is essentially a painting of interesting natural shapes, sunlit in spots, near the corner of a white wall. The mood is happy and quiet. First I carefully painted the logs, one at a time, in rich detail, and textured them while the paint was still wet. Since the logs were the focal point of the painting, they contain the richest definition of texture, color, and design, and the greatest contrast. I played with cool and warm, and light and dark shapes. But by carefully recording their values and textures, these flat shapes became three-dimensional forms. Recovered light shapes and glazed darks offered different textures.

I scraped in the saw marks first, while the shadow color was still wet, then lifted out the patches of sunlight. The saw marks survived the scrubbing and continue uninterrupted through both light and dark areas. Then I wet and painted the background. I painted the shadows on the wall to minimize the impact of the shape of the house by toning down the large mass of white. Then I knifed out the foreground weeds from the darker sap green-dominated washes. I glazed on the large cast shadow on the lower log, leaving the edges sharp. Finally, I glazed on a few details of dark grass and scratched in the edges of the white boards while the shadow wash of brown madder and Antwerp blue was still quite wet.

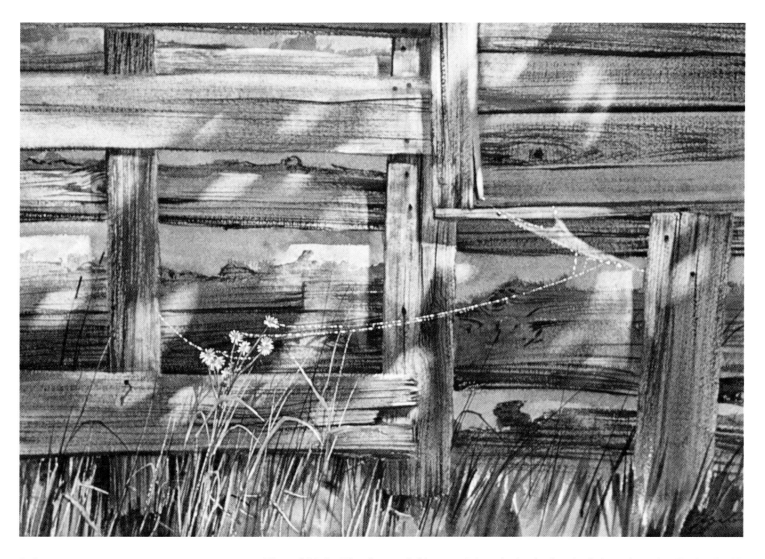

Palette
Burnt Sienna
Sepia
Raw Sienna
Antwerp Blue
French Ultramarine Blue

Play of Light. The focus of this nostalgic painting is the shaded section of a dignified, old building. I defined the shapes through recovered luminosity—that is, lifted-out color—and rich texture. I masked out the flowers first in order to permit free brushwork directly behind them. Then I painted the rich woodgrain with pure sepia on dry white paper first as drybrush. When it dried, I covered it with the shadow color of the wood—burnt sienna, French ultramarine blue, and raw sienna—and lifted out the color where the sunlight struck. The sepia texture of the wood remained, though in a lighter value. The clear, sharp edges of the masked-out flowers contrast with the softer, dark background. I scraped a razor blade on dry paper to get the beadlike character of the cobweb.

The sunlit areas were originally as dark as the shadow areas. I lightened them by lifting them out with a short-haired, firm, bristle brush. You can see the dramatic effect of recovered luminosity. It was helped here by a touch of sepia afterward to accentuate the deeper cracks and inner spaces between the boards. The edges of the shadows vary from sharp to soft depending upon their distance from the object casting the shadow.

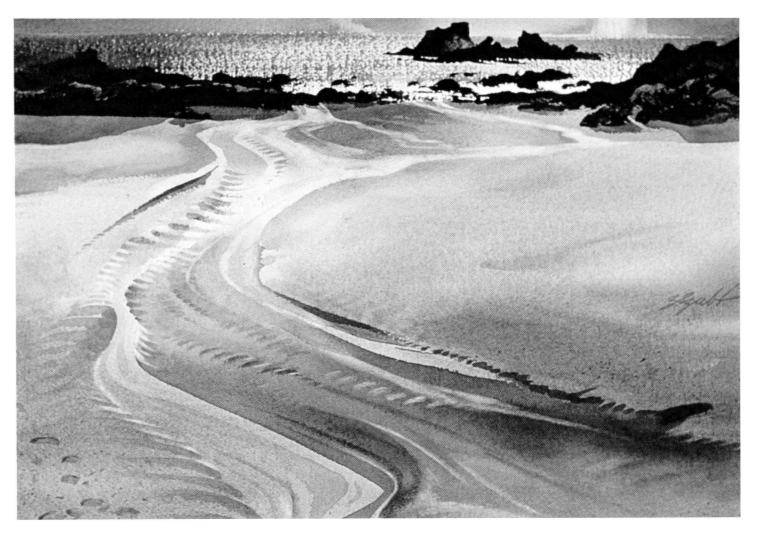

Palette
Sepia
Raw Sienna
Burnt Sienna
French Ultramarine Blue
Winsor Blue

Calm Rivals. Receding tides left this exciting, free pattern in the California sand. I painted the large sand area with a granulating wash of raw sienna, sepia, and French ultramarine blue. I modeled the soft shapes in the sand while the color was wet, but added the darker glazed definitions and wet-lifted some soft highlights after it dried. In addition to the granulating washes, I spattered paint on the foreground sand for a coarse texture. The shadowed footprints show that the sand is wet, and the dark areas in the sand supply drama to the otherwise subtle sand shapes.

I painted the shimmering highlight on the water by dragging a flat brush rapidly on the surface of the paper. I dragged it again for the darker areas. Later, when the paper was dry, I applied the color of the dark rocks (Winsor blue and sepia) and knifed out their edges to model them. I painted their cast shadows last. The long shadows and shimmering (drybrushed) water indicate the low position of the sun. Except for a few drybrush touches in the background, the dynamic design is expressed through glazes and lost-and-found brushstrokes.

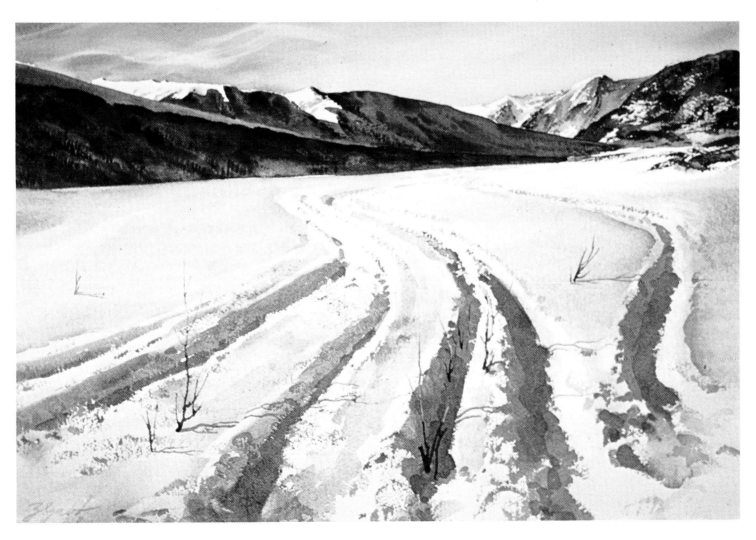

Palette
Raw Sienna
Burnt Sienna
Brown Madder
Antwerp Blue
French Ultramarine Blue

Stage Lighting. The high wind sweeping down over the mountains of Montana constantly reminds me of the battle between sun and snowstorm. The low angle of the winter sun allows the light tone of the blue sky to reflect on the flat surface of the snowfields. I wet the paper and painted the active sky with Antwerp and French ultramarine blues, and with a little raw sienna near the edges of the center peaks—to echo the warm colors on the ground. I then lifted out the streaky clouds from the wet wash. I shaded the dark mountainside and the flat surface of the snowfield with a rich wash of brown madder and Antwerp blue, then painted the forest ascending the slopes with taps of a wet, firm bristle brush loaded with a thick mixture of burnt sienna and Antwerp blue. These overlapping shapes, and the dark wedge-shaped incline on the right, appear to ascend mainly because of a contrast in value. When the paper dried, I drybrushed more of the same color on top to further texture it.

I carefully avoided painting the left-hand slopes of the mountains and the snow tracks where the low sunlight reflected most brightly, but left them white. The shadows of the deep snow tracks were drybrushed and glazed on in several layers of French ultramarine blue and burnt sienna, and a touch of Antwerp blue. I knifed in the sunlit weeds everywhere except where they crossed the dark blue shadows. There, I first scrubbed out the blue before painting them.

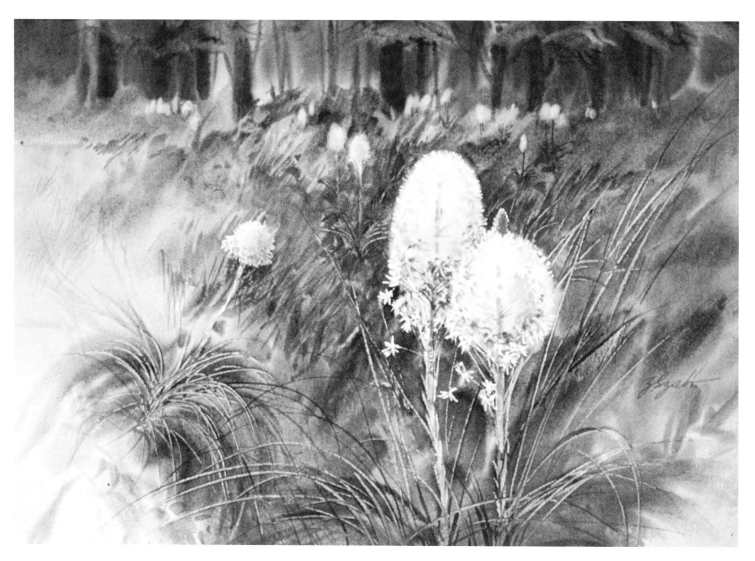

Palette
Raw Sienna
Burnt Sienna
Brown Madder
French Ultramarine Blue
Antwerp Blue

Forest Lanterns. I found yet another surprise in the mountains of Montana: bear grass! These beautiful, little-appreciated wildflowers stole my heart. From a distance they look like bright torches in the dark forests, but seen up close their structure is truly delicate. Receding color (warm in the foreground, cooler in the background) and the correct scale set the scene for a deep, three-dimensional composition. The raw sienna color dominated the flowers, but the color of the rest of the weeds and forest consisted of a neutralized combination of my entire palette.

Before I started to paint, I masked out the outer edges of the main flower and its stem with Miskit. Then, on wet paper, I painted the distant forest and the lush, tall grass, adding more defined brushstrokes as the surface was drying. When the paint was damp, I knifed out the thin grass from the dark background. Through all of this I avoided touching the inner parts of the large area near the blooms. While the paper was still damp, I softly wiped their outer edges, working over and next to the Miskit pattern to indicate soft transitions in value. At the same time, I wet, then lifted out the heads of the distant blooms. Later, after I removed the Miskit, I glazed on delicate flowers within the blooms, hinting at their shapes rather than giving literal details. For example, I modeled the tight little bud on the left-hand side with just a few form-giving soft washes and glazes. The masked-out silhouette carried most of the form. I let tiny masked-out shapes, knifed-out flowers, or carefully glazed on lost-and-found edges define the lacy fragility of the plants' structure. Also, the softly blending values within the flowers make them glow in warm (raw sienna-dominated) light next to a rich, dark, cooler mass of weeds in which Antwerp blue and French ultramarine blue predominate.

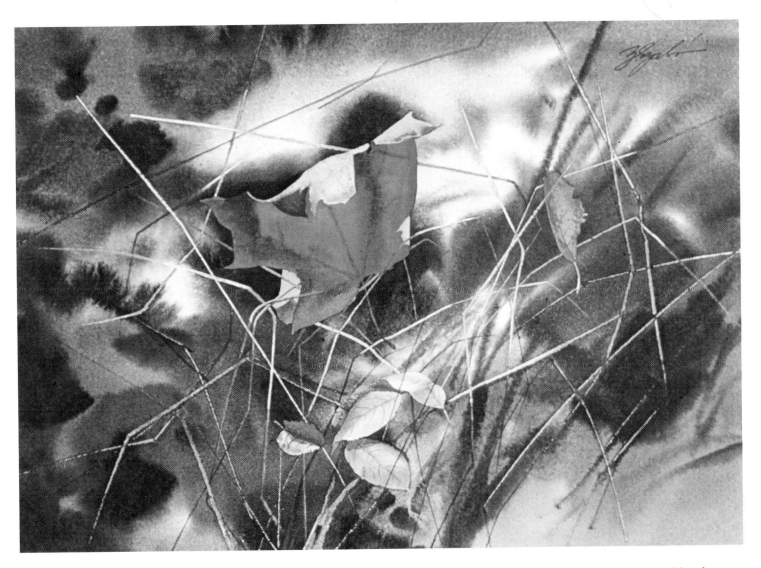

Palette
Raw Sienna
Burnt Sienna
Sepia
Cadmium Red Medium
Antwerp Blue
French Ultramarine Blue

Tangled Resting Place. Momentary frozen abstracts, such as this leaf composition, happen all around us in nature, but we have to take the trouble to look for them. In order to freely apply the background colors on the wet paper, I masked out the sharp-edged leaves and some of the crisscrossed, thin grass stems with Miskit. While the background was still damp, I knifed out more of these stems. Next I removed the Miskit and painted the large leaf with cadmium red, raw sienna, burnt sienna, and sepia. The bright cadmium red color gave the red leaf the feeling of being backlit.

I then painted the smaller leaf and scraped veins into the wet paint with the tip of my brush handle. I colored in the grass stems and added a few thin, dark blades of grass for contrast. The pattern of soft and sharp edges and light and dark shapes in this painting has a harmonious balance. Even the smaller, less significant details are balanced in shape and consistent in treatment with the rest of the painting.

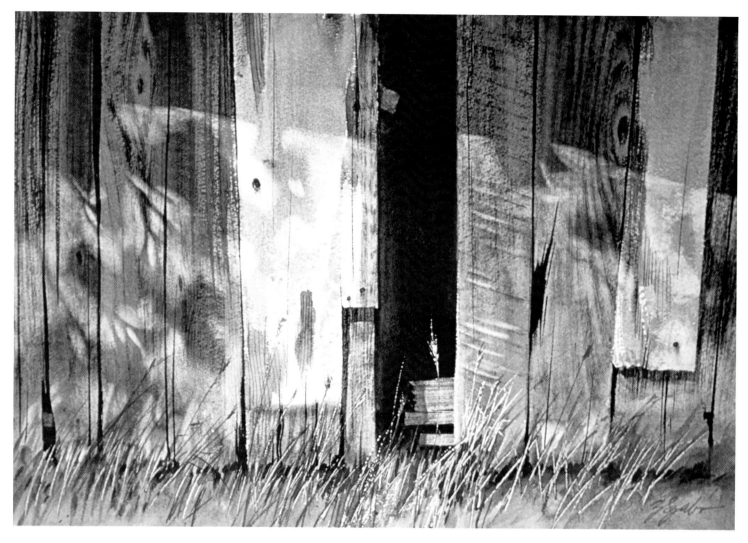

Palette
Raw Sienna
Burnt Sienna
Sepia
French Ultramarine Blue
Antwerp Blue
Manganese Blue

Sunny Boy. The dappled shadow pattern on the textured old wood in this almost abstract painting created interesting shapes and gave me the opportunity to use recovered luminosity to the fullest extent. I first masked out the clearest light weeds near the center of the painting with Miskit, then drybrushed on the woodgrain on dry white paper using a heavy consistency of sepia. I painted the shadow value of the old, natural wood with French ultramarine blue and burnt sienna. To create the effect of woodgrain on the isolated patches of raw wood on the white-painted board, I scraped the tip of my brush handle into the wet sepia drybrush brushstrokes.

I painted the shadows on the white boards with manganese blue, French ultramarine blue, and a touch of burnt sienna, then wet and blot-lifted off the sunlight carefully leaving the shadow shapes intact. The continuous sepia woodgrain established first shows through the glazed, shaded areas as well as in the brightly lit sunny areas, where the glaze overwash was lifted out. Scrubbing off part of the top color only lightened the value of the sepia slightly. I was careful only to wipe out only the *sunny* patches of light, not the darker shadowed areas—a mistake often made by students. I painted the dark opening in the wall with a combination of sepia and Antwerp blue. I then removed the latex mask from the central weeds and painted them and the other weeds raw sienna, burnt sienna, and a little sepia. Finally, I touched up the deep cracks between the boards with sepia and added the rusty nails with burnt sienna and sepia.

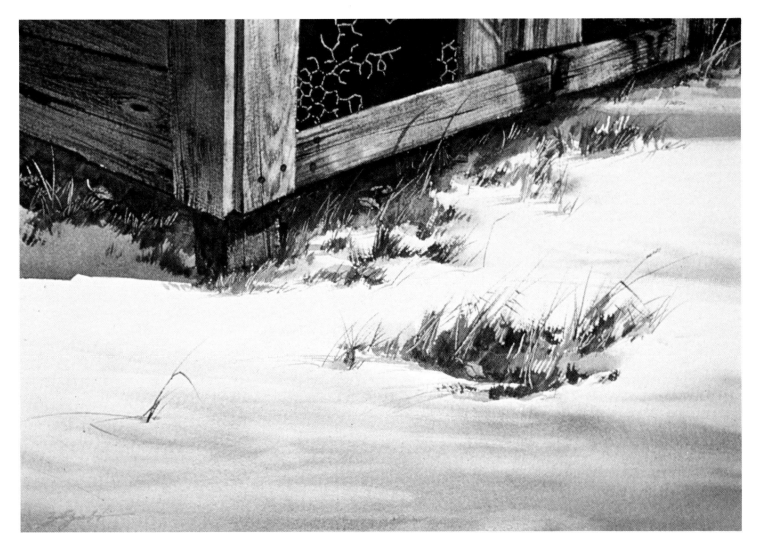

Palette
Sepia
Brown Madder
Raw Sienna
Burnt Sienna
French Ultramarine Blue
Winsor Blue

Abandoned Cage. Each of these differently textured surfaces required a different application of paint. I textured the woodgrain on the wooden structure with a rich value of drybrushed sepia on the white paper first and when it dried, glazed over it with a wash of the shaded wood color—burnt sienna and French ultramarine blue. When it was dry, I wet and wiped out the sunlit portion, exposing a light value of the weathered wood beneath. The rich texture of the woodgrain remained after scrubbing because of the staining strength of the sepia drybrush.

I painted the clumps of grass with a drybrush technique with fast, upward bristle-brush strokes, using raw sienna and burnt sienna and a little sepia. I added a few random knife-strokes for the lighter blades. Where the knife carried the excess color into the dry area, it looked like dark weeds. I added a few more weeds with a rigger brush and painted the leaves. I painted the soft shadows on the snow on wet paper, but carefully kept the edges of the weeds and of the shadows cast by the shed's corner sharp because it and the neighboring objects were close to the surfaces casting them. Finally, I knifed out the chicken wire fence from a dark wash of brown madder and Winsor blue while it was still damp.

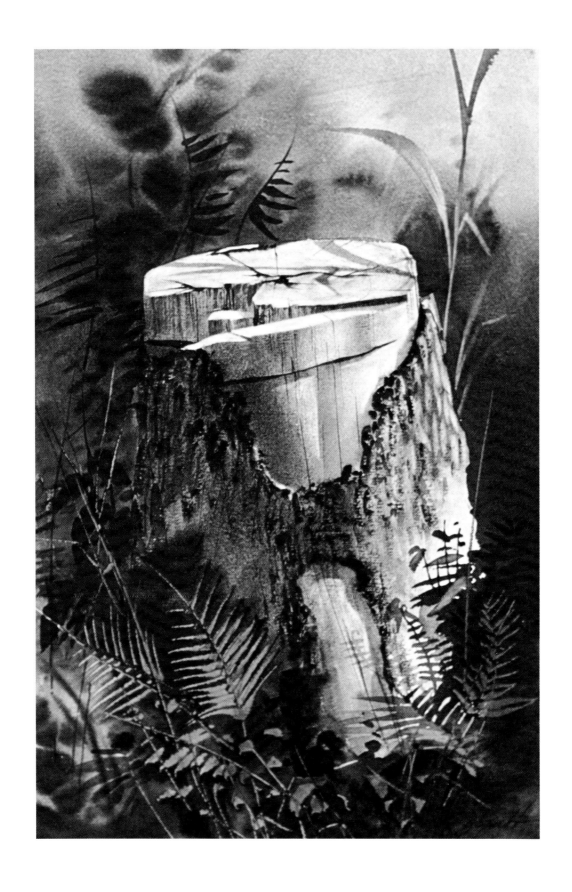

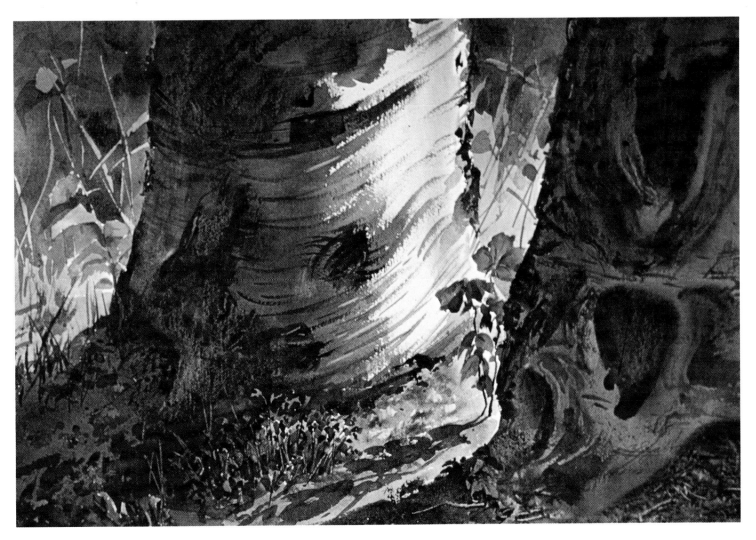

Palette
Raw Sienna
Burnt Sienna
Cadmium Red Medium
Brown Madder
French Ultramarine Blue
Antwerp Blue

Palette
Raw Sienna
Burnt Sienna
Sepia
French Ultramarine Blue
Sap Green

Sanctuary of Innocence. Small objects look even smaller when they're placed next to large objects. This little knot of colorful flowers at the roots of the old birch was well sheltered and quite tiny in contrast to the overpowering birch. I textured the gnarled old birches with sepia and glazed the shadow color over them with Antwerp blue, brown madder, and burnt sienna. The drybrush strokes on the white sunlit birch curve with the form. I painted the red petunias with light glazes of cadmium red medium, brown madder, and a touch of French ultramarine blue. I painted the dark background around the tiny blue violets and left them exposed as negative shapes. Later I glazed French ultramarine blue over the entire area, which tinted the flowers blue. I treated the background weeds loosely with glazes of raw sienna and French ultramarine blue, knifing out sections here and there.

Stripping (Left). Here was a good opportunity to paint texture: an old stump, covered with saw marks, cuts, and chips on its hard wood, encased in a half-torn sheath of bark. The lush green weeds at its base are richly alive and surround what was once a proud old tree. Before I textured the grain of the split wood shapes, I masked their edges with masking tape on dry paper. I painted the texture of the wood and bark first with sepia drybrush on the white paper. Then I glazed the darker wood color on top of it, and lifted it off later to model the light side. (I painted deep cracks later, recovering their dark value, which was lost during the scrubbing procedure.) For the dark green weeds, I used a dark wash dominated by sap green, letting the brushstrokes blend as they touched one another. Just as the shine of the wet paint was disappearing, I knifed out the light weeds, exposing the sap green-stained paper in a light value. The firm palette knife can remove leaflike shapes beautifully.

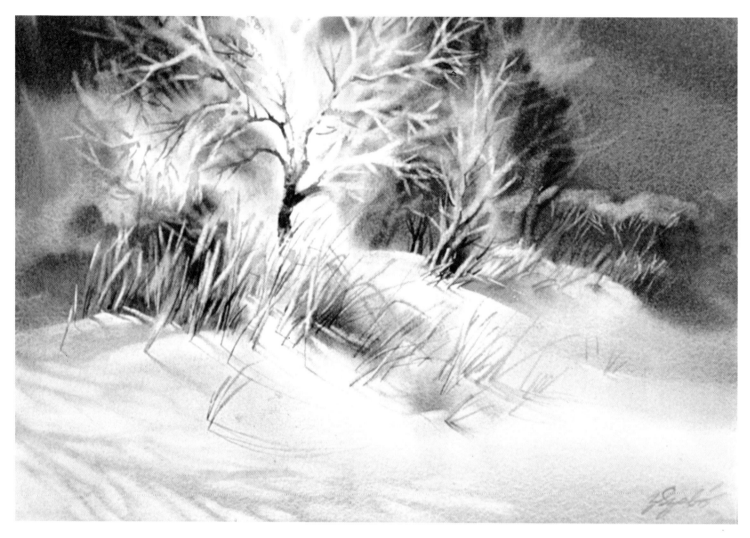

Palette
Manganese Blue
French Ultramarine Blue
Antwerp Blue
Raw Sienna
Burnt Sienna

Snow Flash. Hoarfrost is one of winter's beautiful gifts. When fog condenses on cold, solid objects, they become covered with a furry coat of white frost. After the fog lifts and the sun bursts through, these frosty trees and weeds light up like white torches. I painted most of this study on wet paper. I worked around the largest white shapes, and wet-lifted others from washes containing manganese blue. (Manganese blue in a wash makes most other colors it's mixed with lift off easily.)

First I applied a dark background wash of manganese blue, French ultramarine blue, and burnt sienna. When the paper was dry, I lifted out the fluffy white branches. I added the dark, warm-colored twigs last, on dry paper. To define the large white shape of the tree, I glazed some background color around the white branches. The lost edges of these brushstrokes blended softly into the wet-in-wet shapes. The surface of the snow was painted a dark shadow color. I gently lightened it as I lifted out the sunlit areas from the cast shadow of the tree at the lower left, until it looked sunny, but textured. I painted the weeds and their shadows with fast brushstrokes to keep them brittle, but delicate-looking.

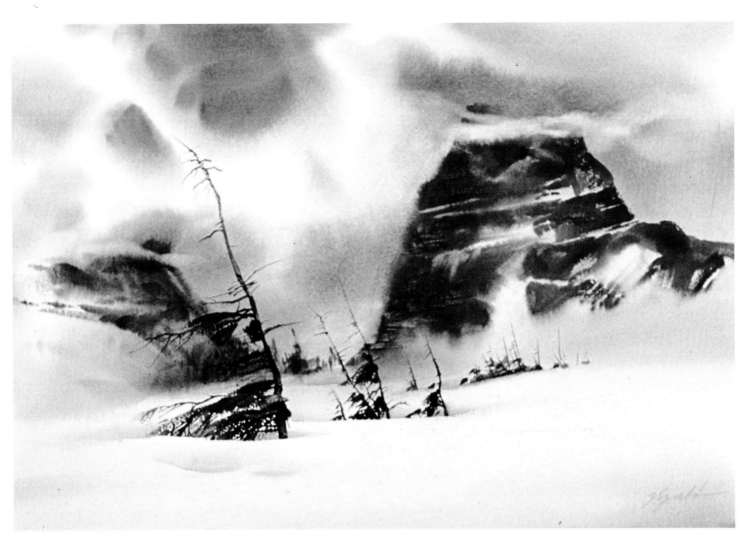

Palette
Brown Madder
Raw Sienna
Antwerp Blue
French Ultramarine Blue

Indian's Spring. In July, Logan Pass in Glacier National Park is still a winter wonderland. There is a 10-foot (3-meter) layer of snow covering the incredible peaks surrounding the pass, and only the tips of the battered alpine first stick out. The clouds are constantly ripped open as they roll and crash into the jagged rocky peaks. On wet paper, I washed in the blue sky, which shows through the roaring storm clouds, with Antwerp blue and just a touch of brown madder. I slapped these shapes onto the drenched white paper and allowed them to spread freely, while carefully reserving white spaces for the clouds. Then I painted the simple shape of the distant mountain on wet paper and quickly lifted out the cloud covering it with a thirsty brush while the paint was wet. I painted the peaks with brown madder and Antwerp blue and, before the color had a chance to stain the paper, I knifed out the sharp-edged white snow by firmly pressing my palette knife into the wet washes.

The trees and snow were added last, on dry paper. Before beginning the trees, I masked out the lower edges with tape where they're covered by snow. Then I drybrushed on the green foliage with raw sienna and French ultramarine blue, and knifed in the scrawny branches with Antwerp blue and brown madder. The shaded snow beneath them was created by lost-and-found brushstrokes of Antwerp blue and brown madder. By carefully scaling the clusters of trees to the peaks and to each other I help provide the illusion of depth.

Index

Edited by Bonnie Silverstein
Designed by Bob Fillie
Production by Hector Campbell
Set in 11-point Century Schoolbook